Heavenly Bodies

THE PHOTOGRAPHER'S GUIDE
TO ASTROPHOTOGRAPHY

P9-ECL-937

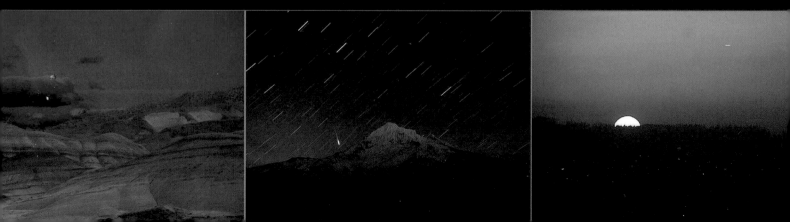

To my wife
KATHRYN PYLE KRAGES
Don't wait up, I'll be home soon.

Copyright © 2004 by Bert P. Krages, Esq.
All photographs by the author.

All rights reserved.

Published by:
Amherst Media®
P.O. Box 586
Buffalo, N.Y. 14226
Fax: 716-874-4508
www.AmherstMedia.com

Publisher: Craig Alesse
Senior Editor/Production Manager: Michelle Perkins
Assistant Editor: Barbara A. Lynch-Johnt

ISBN: 1-58428-116-2
Library of Congress Control Number: 2003103026

Printed in Korea.
10 9 8 7 6 5 4 3 2 1

No part of this publication may be reproduced, stored, or transmitted in any form or by any means, electronic, mechanical, photocopied, recorded or otherwise, without prior written consent from the publisher.

Notice of Disclaimer: The information contained in this book is based on the author's experience and opinions. The author and publisher will not be held liable for the use or misuse of the information in this book.

Contents

1. A New View of the Universe

Astrophotography is a very feasible genre, yet most photographers all but ignore the night sky. A major reason, of course, is that photography requires light, and night skies tend to be rather dark. Another reason is that most photographers give little thought to including celestial objects in their images—except for the occasional sunrise or sunset. However, the night sky is filled with beautiful objects and provides an enormous amount of material to those photographers who know how to record it. By learning how to photograph the night sky, photographers can greatly increase their opportunities for artistic expression.

The two major obstacles that keep many photographers from attempting astrophotography—equipment and ignorance of astronomy—are easily overcome. Only basic equipment is needed to do a good portion of astrophotography. Not only can a lot be done with a camera and tripod, this basic setup provides a very versatile means of making images. Likewise, it is not all that difficult to learn enough about astronomy to plan and execute incredible images. Many people do not realize that magnificent celestial objects such as the Milky Way, Orion Nebula, and the Pleiades star cluster are neither difficult to find nor to photograph. Learning more about the night sky will give you a new view of the universe and increase your consciousness of the night environment.

This book will provide the information you need to learn how to do astrophotography with conventional photography equipment and introduce you to photography with intermediate-level astronomical instruments. It

Only basic equipment is needed to do a good portion of astrophotography.

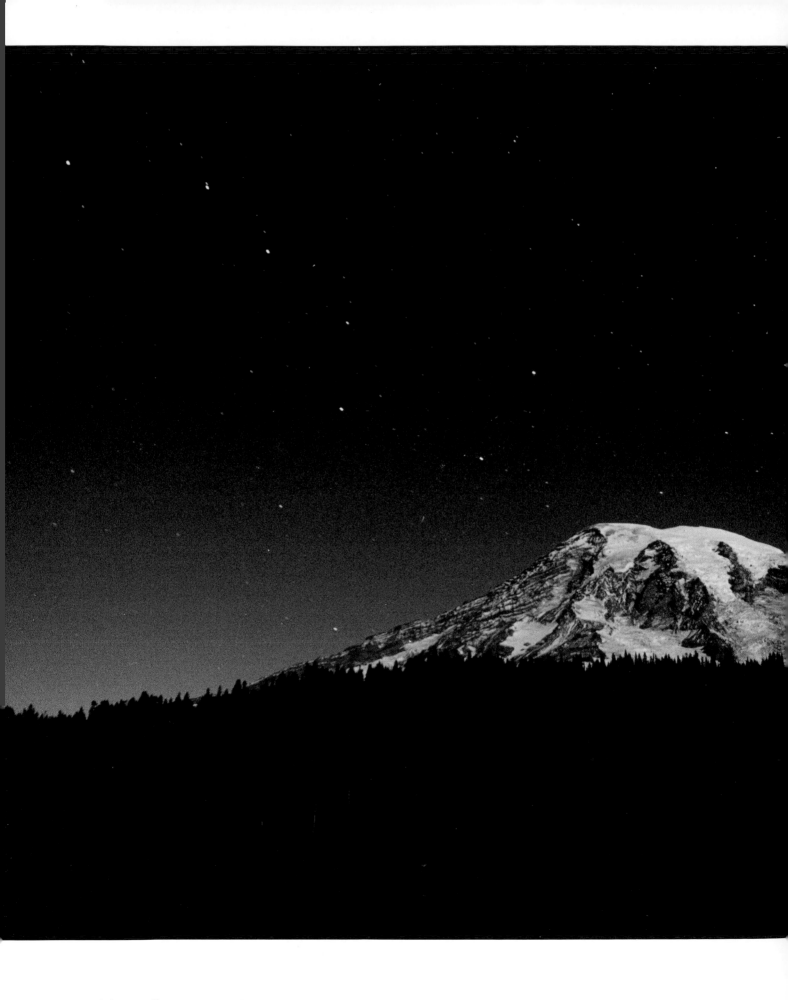

Left—Thousands of people photograph Mt. Rainier in Washington State each year. Photographing landmarks at night provides new opportunities for expression. Lens: 24mm. Exposure: 30 seconds at f/4. Film: Fuji Superia 400. **Above**—A few stars can add some elegance to an otherwise uninteresting scene. Lens: 50mm. Exposure: 15 seconds at f/2. Film: Kodak E100SW.

largely avoids discussing highly specialized astrophotography applications such as CCD cameras, hypersensitized films, and digital enhancement techniques. Instead, it emphasizes how to get the most performance from conventional gear that many photographers already have. It also makes suggestions for getting started with photography using astronomical instruments. The book does not presume a prior background in astronomy. To take good photographs, one does not need to know about physics, black holes, red shifts, or either the special or general theory of relativity. You do need to know where the planet Earth is located. If you are unsure, look down.

Modern emulsions have greatly enhanced the opportunities for astrophotography with conventional equipment. Twenty years ago, only the brightest stars could be recorded with a camera and tripod without significant trailing. Compare photographs of the "W"-shaped constellation Cassiopeia shot with slow and fast films. **Facing Page**—*Lens: 50mm. Exposure: 10 seconds at f/2. Film: Konica Centuria 800.* **Above**—*Lens: 24mm. Exposure: 15 seconds at f/4. Film: Fuji Velvia. Exposure: EI 40.*

Sometimes the Best Light Happens at Night

There is a lot more to the night sky than meets the eye. Since it is filled with beautiful objects, the amount of material to photograph becomes enormous once you understand how to record it. If you already have experience with a genre such as landscape photography, learning astrophotography techniques can help expand your repertoire and create more opportunities to make images.

One of the benefits of learning astrophotography is that it can be a source of adventure. Some interesting astronomical event happens just about every week. Many, such as meteor showers, occur at the same time every year. Other events such as comets are not as predictable but happen more frequently than you may suspect. Furthermore, the ability to predict events goes hand in hand with the ability to plan how to photograph such events.

Traditionally, astrophotography has been the domain of astronomers interested in recording images of the objects they observe. Astrophotography has also been a major research tool in astronomy for over a century. In prior years, the slow photographic emulsions available meant that long exposures and special tracking devices were required to make even basic images. Until about twenty years ago, equipment capable of precise tracking was mostly available at research institutions or large public observatories. Astrophotography was an established tool for astronomical research but not widely practiced by amateurs. The quality of astronomical equipment available to amateurs until recently also discouraged photographers from attempting

astrophotography. In the past, only the most dedicated amateur astronomers were interested in investing in the highly specialized equipment needed to track and photograph celestial objects.

However, improvements in films within the last ten to fifteen years now allow photographers to record celestial objects more effectively than could be done with the emulsions and instruments available previously. The key to becoming proficient is to learn some basic astronomy and to understand the influence that light and optics have on the ability to record celestial objects.

Getting Started: Equipment

There is a common misconception that astrophotography requires expensive telescopes operated at very high magnifications. This misconception is partly due to advertisements of junk telescopes boasting magnifications in the range of 300 to 600 times. In reality, most advanced astrophotography is done with telescopes with focal lengths in the range of 500 to 2000mm. These focal lengths are not that much longer than the focal lengths used in conventional photography. In fact, many of the highest quality astronomical images have been made with telescopes having focal lengths of less than 700mm. Furthermore, most highly accomplished astrophotographers use conventional photographic systems to make a good portion of their images. Many celestial objects are too large to be imaged with anything but conventional lenses. If you are interested in becoming proficient at astrophotography, it is important not to underestimate the capabilities of conventional equipment.

Since most images are made in the dark, simplicity is a virtue.

The best way to get started in astrophotography is to use conventional photographic equipment and acquire experience before attempting telescope techniques. Many photographers with limited knowledge of the night sky can learn to incorporate celestial elements into the kind of images they already know how to make. This approach not only facilitates learning the basics of amateur astronomy, it avoids the frustration of having to struggle with unfamiliar equipment to get images of unfamiliar objects.

Another reason to start with conventional equipment is that the optics are optimized for making images. This is not always the case for telescopes, which are often designed solely for visual applications. For example, many telescopes cannot focus at infinity when used with a camera adapter. For these and other reasons, it is better to learn how to use conventional photographic equipment for astrophotography before attempting to select and operate a telescope-based system.

Acquiring equipment to get started in astrophotography is not difficult: all that is needed is a tripod, camera body, lenses, and a few accessories. Binoculars are also good to have. If you were hoping to get by with the supposedly antiquated systems from the 1970s, it will be a dream come true. Electronic features such as metering and autofocus are rarely helpful in astrophotography and some, such as illuminated viewfinders, can be a hindrance. Since most images are made in the dark, simplicity is a virtue.

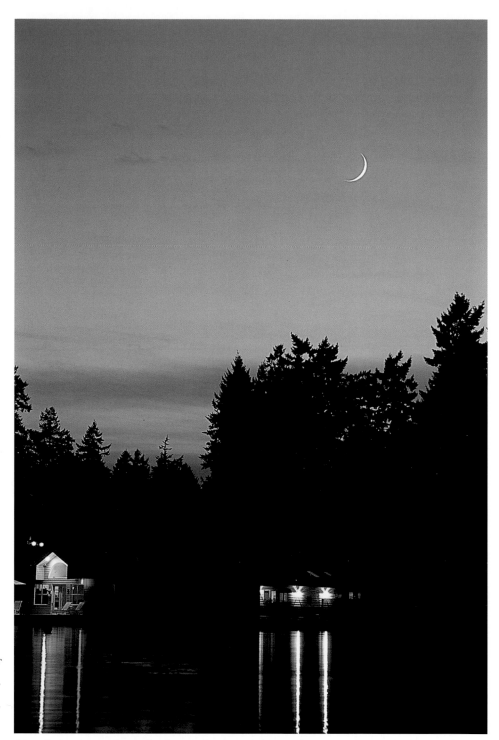

Telephoto lenses encompass narrow angles of view but make celestial objects appear larger than normal. Lens: 180mm. Exposure: ⅛ second at f/2.8. Film: Fujichrome Provia F.

Simplicity is particularly favored when taking photographs at 3:00AM when the mind is less capable of handling complex matters.

Tripods. Tripods may not be the most glamourous items, but they serve as the foundation for astrophotography where the exposures are long, and the small points formed by stars emphasize the slightest movement during the exposure. Rigidity, of course, is the most important criterion for a tripod, and one should select a model with sufficient robustness to handle the anticipated loads. In general, you should purchase the most rigid tripod consistent with your budget and the need for portability. Even though inexpensive tripods may appear suitable for use with 35mm camera bodies with normal

Wide-angle lenses encompass large angles of views but make celestial objects such as the Moon appear smaller than normal. Lens: 24mm. Exposure: 1/15 second at f/2.8. Film: Fujichrome Provia F.

and wide-angle lenses, the typical exposures in astrophotography are long enough that it is often impossible to detect slight movements, which degrade images. The demands on tripods increase substantially when used to support heavy equipment or tracking devices.

Most quality tripods allow the photographer to install different kinds of heads for holding and positioning the camera. Heads comes in either the ball or pan type, and both are suitable for astrophotography. Ball heads are the easiest and fastest to position and can be locked with a single control. Pan heads are moved separately about horizontal and vertical axes, and while slower to set up than ball heads, they can be adjusted with more precision. However, some pan heads cannot be pointed straight up, which is a significant limitation for astrophotography. In addition, most pan heads have handles that stick out and can be inadvertently jarred when working in the dark. Regardless of which type head you prefer, it should be sufficiently strong to support the load it will carry. Heads that are used with quick release plates are highly recommended for astrophotography since they expedite setting up and switching camera bodies.

Camera Bodies. The most versatile camera format for astrophotography is the 35mm single lens reflex (SLR) since this format has a wider variety of films and lenses available than other formats. In many respects, cameras that have mostly manual features are better suited for astrophotography than automated models. The biggest problem with modern camera bodies is that most require battery power to open and close the shutter. Since exposures in astrophotography can take as long as several hours, relying on batteries can be a real hindrance. It is also important that the camera be able to accept a cable release, which some modern cameras cannot do.

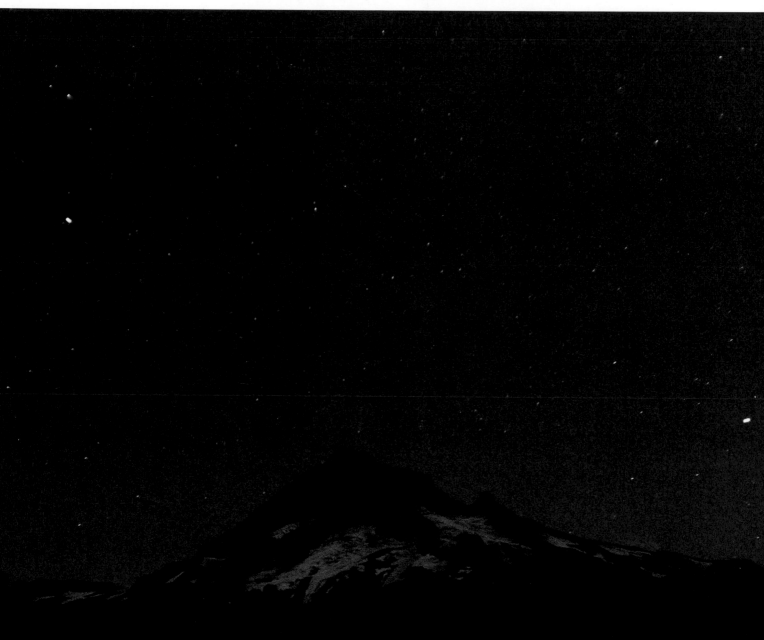

Testing the optical performance of individual lenses is important. This lens shows an aberration known as coma, particularly toward the edges. Camera: Mamiya C220. Lens: 80mm. Exposure: 15 seconds at f/4. Film Fujicolor NHG II 120 format.

The focusing screen is another important consideration in selecting a camera. Ideally, a screen will be bright and easy to focus on point-sized objects. The best kinds for astrophotography have a fine-ground matte surface. Screens with Fresnel lenses, split image rangefinders, and microprism focusing are more difficult to use for astrophotography. Although Fresnel lenses brighten the corners of a screen, they prevent stars from focusing to small points and thus make it difficult to focus precisely. Rangefinder and microprism screens are not useful for astrophotography since they do not focus on points well and black out when used with optics with higher focal ratios such as telescopes. Illuminated viewfinders should be avoided if possible since they tend to degrade night vision and hinder viewing at night. If you do use a camera with an illuminated viewfinder, it may be necessary at times to shut the camera off when focusing and composing.

Illuminated viewfinders should be avoided if possible. . . .

Other useful features are mirror lockup and self-timers. Mirror lockup is particularly important when using long lenses or telescopes to photograph solar system objects such as the Moon and planets. Since photography of these objects requires great magnification and relatively short shutter speeds, mirror slap can degrade images. Similarly, a self-timer provides extra time that allows tripod or mount vibrations to die down before the shutter opens. Some cameras, such as Nikon's manual bodies, have a pseudo-lockup feature where the mirror flips up when the self-timer is activated.

Point & Shoot and Digital Astrophotography?

Can astrophotography be done with simple point & shoot cameras? Are digital cameras any good for astrophotography? The main problems with using point & shoot cameras is the limited control over focus and exposure. Conventional digital cameras work fine for relatively short exposures but suffer from "noise" that degrades the image when long exposures are made. While these kinds of cameras are not suitable for most astrophotography, some limited applications are possible. The afocal technique described in chapter 6 for imaging through telescopes can be done using digital and point & shoot cameras. Similarly, some point & shoot cameras such as the Olympus Stylus Epic have reasonably fast lenses with flash controls that are sophisticated enough to use the combined Moon and subject technique described in chapter 4. However, the inability to control the aperture setting and shutter speed preclude good control over exposure and depth of field.

This lunar eclipse was photographed using an Olympus Stylus Epic point & shoot camera. Although the Moon is an easy object to photograph, the lack of control over focus and exposure resulted in a fuzzy image.

Popular 35mm camera bodies for astrophotography include the Olympus OM-1 and Nikon F2, both of which date from the 1970s. The F2 is more expensive but has more accessories and better lenses. However, the OM-1 is a highly regarded camera body that created a big sensation when it was introduced in the early 1970s. It is available on the used market at good prices, though accessories and lenses are more limited than for other systems. It can be even harder to find a double-knit polyester shirt to complete the OM-1 "swinger look."

Other kinds of cameras can be used for astrophotography but are not as versatile as 35mm SLRs. The key requirements are the ability to manually focus and set the shutter speed for long duration exposures. The most popular medium format camera for astrophotography is the Pentax 67.

Lenses. Astrophotography is one of the most demanding applications of optics, so it is important to understand the basics of optical performance when selecting and using lenses. The main considerations for selecting lenses for astrophotography are aperture, focal ratio, and focal length. Although most photographers generally understand these terms, they have particular relevance to astrophotography, and it is helpful to know how they relate to each other. Other important considerations are the freedom from aberrations, speed, and construction of the lens.

The aperture of the lens is important to astrophotography because it determines how effectively the lens will collect light from point sources such as stars. Lenses with larger apertures can record fainter stars than lenses with smaller apertures given the same amount of exposure time. The maximum aperture of a lens is the diameter of the front element when the lens diaphragm is wide open. If the lens diaphragm is closed down, the effective aperture will be reduced accordingly. You can calculate the effective aperture of a lens by dividing the focal length by the focal ratio to which the lens is set. For example, the effective physical aperture for a 50mm lens will be 25mm when the lens is set at $f/2$ (50mm \div 2) and 12.5mm when the lens is set at $f/4$ (50mm \div 4).

Although the ability of a lens to collect light from point sources of light depends on the aperture, the ability to collect light from area or diffuse sources depends on the focal ratio. Lenses with small focal ratios collect light better from landscape elements and diffuse celestial objects such as nebulae than do lenses with high focal ratios. The focal ratio of a lens is determined by dividing the aperture by the focal length. For example, a 50mm lens with an aperture of 50mm will have a focal ratio of $f/1$. If the diaphragm is closed down to 25mm, the effective focal ratio decreases to $f/2$. Specific focal ratios, such as $f/2$ or $f/2.8$, are known as f-stops. Each time the diameter of the diaphragm is reduced by 29 percent, the amount of light that will pass through the lens decreases by half. The standard progression of f/stops in photography that reflect a progressive light reduction of 50 percent is $f/1$, $f/1.4$, $f/2$, $f/2.8$, $f/4$, $f/5.6$, $f/8$, $f/11$, $f/16$, and so on.

Astrophotography is one of the most demanding applications of optics. . . .

The focal length of a simple lens is the distance between the physical center of the lens element and the film plane. However, photographic lenses almost always have multiple elements, which affect their optical behavior. For these lenses, the focal length is the distance between the optical center of the lens and the film plane. For 35mm cameras, lenses with focal lengths ranging from 45 to 60mm are called normal lenses because they approximate the angle of view of unaided vision. Wide-angle lenses have shorter focal lengths and telephoto lenses have longer focal lengths. Focal length is an important consideration because it determines the area of view encompassed by the image and the magnification of the subject.

The selection of lenses for particular applications will depend on the photographer's objectives. Most photographers consider focal length to be the dominant criterion since it controls the angle of view encompassed by the image, but aperture and focal ratio can still be critical to the kinds and extent of objects recorded. The most versatile lens for the beginning astrophotographer is a 50mm lens with a focal ratio between f/1.4 and f/2. Such lenses have reasonably large apertures, fast focal ratios, and angles of views that are useful for recording constellations and incorporating celestial bodies into images. Wide-angle lenses are useful for images encompassing landscapes, and telephoto lenses are useful when magnification is needed. However, all lenses have trade-offs in terms of angle of view, the ability to record stars, and the ability to record areas and shapes.

The quality of the optics in a lens is important, but most of the prime lenses made by the major manufacturers perform well enough for astrophotography. Nonetheless, all lenses have imperfections known as optical aberrations, and factors such as manufacturing variations warrant testing the performance of individual lenses. There are several kinds of aberrations, but to simplify matters, the ones most relevant to astrophotography are caused by the outer area of a lens performing differently than the inner area. From the manufacturer's perspective, it is possible to correct aberrations by making lenses with various combinations of lens elements, which is why photographic lenses typically have several elements.

Wide angle and normal lenses must be stopped down one or two f/stops. . . .

From the photographer's perspective, the effects of aberrations in astrophotography are controlled by stopping down the lens. Reducing the diaphragm opening reduces aberrations by blocking the light at the outer edges of the lens. Wide angle and normal lenses must be stopped down one or two f/stops when used for astrophotography to reduce aberrations to acceptable levels. Some lenses may produce acceptable results over most of the image when stopped down by one stop but will require two stops to reduce aberrations all the way to the corners. For example, the Nikkor 50mm f/1.4 lens will usually produce an acceptable image over about 80 percent of the frame when set at f/2 but must be stopped down to f/2.8 to control aberrations near the corners. However, some wide angle and normal lenses do not perform well until they are stopped down to two stops. Most telephoto lens-

es perform well when used wide open because they have a narrower angle of view.

Fast lenses (those with low focal ratios) are easier to use than slow lenses.

Fast lenses (those with low focal ratios) are easier to use than slow lenses. Not only do fast lenses produce brighter images on the focusing screen, the reduced depth of field makes it easier to discern the point of focus. This is a significant advantage since focusing under dark skies can be challenging. However, the optical performance of such lenses may be no better than the slower versions made by the same manufacturer. For example, both the Nikkor 50mm f/1.4 and 50mm f/1.8 lenses need to be set at f/2.8 to reduce aberrations from corner to corner. Nonetheless, even though the most usable focal ratio of these lenses is the same, it is easier to focus and compose images with the f/1.4 version because of the brighter focusing screen.

The design and construction should be considered when selecting a lens for astrophotography. Prime lenses are more suitable for astrophotography than zoom lenses because they tend to be better corrected for optical aberrations and typically have larger apertures. In addition, some zoom lenses tend to slide over time when pointed upward. The sliding causes the focal length to change during the exposure, which severely disrupts the image.

Ease of use in the dark should also be considered. Click stops on aperture rings allow you to determine the position of the f-stop ring by feel when setting up an image in the dark. Lens caps and mounts should facilitate the straightforward changing of lenses. Since astrophotography is sometimes done when it is cold outside, focusing rings should be easy to operate when wearing gloves or mittens. It is also easier to ensure good focus at infinity if the lens does not focus past infinity. Autofocus is unnecessary, although some cameras are sufficiently sensitive to autofocus on some celestial objects. However, manual focus lenses are less prone to inadvertently shifting their focus points than autofocus lenses and perform better in that regard.

Accessories. Since most astrophotography occurs at night and relies on long exposures, special attention should be given to accessories. To the extent feasible, accessories should be selected that are easy to use in the dark, reasonably convenient to store without damage, and easy to find when dropped.

Lens hoods are important accessories that enhance image contrast by reducing the glare from peripheral lights. They can also delay the onset of dew when photographing on cold nights. It is a good idea to have a hood for each of the lenses you intend to use for astrophotography. Lenses that have built-in hoods are very convenient when working in the dark.

Flashlights are almost essential when photographing in the dark, although you should learn to do routine tasks such as setting f/stops or changing lenses without them. The need for illumination varies during an astrophotography session, and it can be helpful to have two or three kinds of flashlights. A conventional bright flashlight is recommended when walking about unfamiliar sites or those with hazards such as cliffs, stairs, and bodies of water. Conventional flashlights are also good for situations that require acute vision

such as searching for a screw-in lock that has fallen from a cable release into the grass. (Don't laugh—these things happen!)

The main drawback to conventional flashlights is that white light degrades night vision. The solution is to use red flashlights since red light does not affect night vision as much as other colors. Models that use two AA batteries are a good choice since their light output is adequate for most uses, they fit easily into pockets, and can be held in your teeth when working with both hands. Conventional flashlights can be modified by covering the lens with red vinyl tape. Although the light output is diminished, the red tape method has the advantage that the tape can be removed if for some reason bright white light becomes desirable. Red LED flashlights are another option and are available from vendors of astronomical equipment. Once the eyes become fully accustomed to the dark, very little illumination is needed for most tasks, and some astrophotographers prefer to use a miniature red flashlight for close tasks such as making camera adjustments.

Using a superior quality cable release can prevent unnecessary aggravation in the field. For astrophotography, cable releases should be sufficiently durable so as to withstand repeated and sustained use. Most exposures in astrophotography require the cable release to be locked, which increases the strain on the device. Some generic and lesser brands may fail after only an hour of continuous use. Some quality cable releases include models made by Minolta, Nikon, Prontor, and Linhof. Length is another concern since cable releases seem to develop a special tendency to flop around when used in the dark. Inadvertently snagging a release during an exposure can be extremely frustrating when it wrecks an otherwise well-executed shot. In addition, short releases seem less inclined to dangle in front of the lens.

Timers are another useful accessory, especially when you are working with two or more cameras. Those that give audible signals are recommended since they free you from having to count seconds or monitor a display. Ease of use is generally more important than precision, and inexpensive mechanical kitchen timers are a good choice. If you will be photographing in cold environments, select a timer that can be easily operated with gloved hands. Many astrophotographers like to use digital watches with illuminated faces and built-in timers.

Many astrophotographers like to use digital watches with illuminated faces. . . .

Some accessories are helpful when trying to compose images through a dark viewfinder. For instance, a bubble level mounted in the flash shoe is the best means of ensuring a level horizon. The best models are made by Hama. A focusing hood—or even a cloth you can drape over your head and the camera—makes composition easier when glare from nearby lights interferes with seeing through the viewfinder.

Binoculars. Binoculars are very useful in astrophotography, although they are not essential. Not only can they be used to discern objects that are masked by light pollution or too dim to see with the unaided eye, they can detect terrestrial objects that would otherwise be invisible at night to the unaided eye.

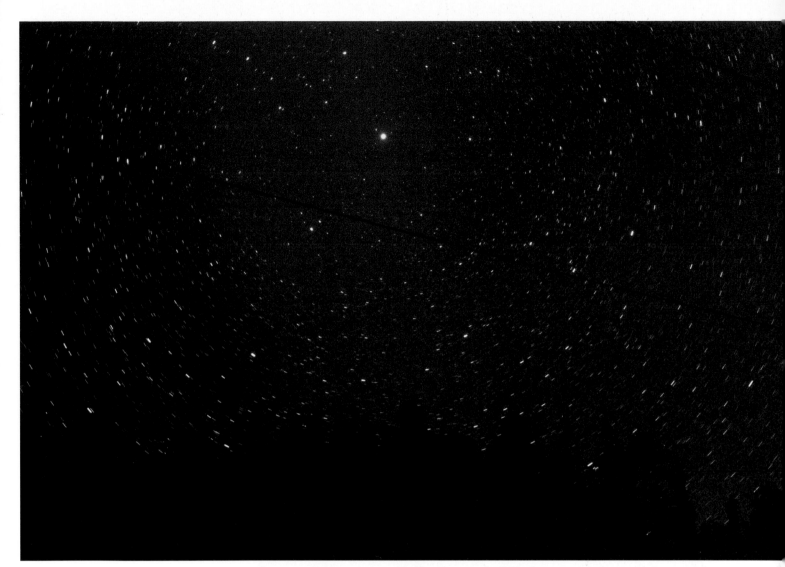

Foreground obstructions and utility lines can be difficult to see with the unaided eye, particularly in dark areas. Scanning the anticipated field of view with binoculars before making an image can help detect extraneous elements before the image is made.

This can be particularly important in landscape work with conventional lenses since binoculars can discern obstructions that would otherwise ruin images.

The optical performance of binoculars is designated by two numbers, such as 7 x 35. The first number indicates the magnification and the second describes the diameter of the front lenses in millimeters (mm). A 7 x 35 binocular will magnify the view by 7 times and has front lenses that are 35mm in diameter. For astronomy, the most important consideration for selecting binoculars is the exit pupil, since this determines the amount of light transmitted to the eye. The exit pupil is the diameter of the light beam leaving the eyepieces and can be calculated by dividing the diameter of the front lenses by the magnification ratio. For example, the exit pupil of a 7 x 35 binoculars is 5mm (35mm ÷ 7), and the exit pupil of a pair of 7 x 21 binoculars is 3mm (21 ÷ 7). Ideally, the exit pupil of the binoculars should be the same as the diameter of the viewer's pupils. If the exit pupil is smaller, the binoculars will transmit less than the maximum amount of light that can pass through the

pupil. If larger, some of the collected light will be wasted since the light that falls outside the pupil will not reach the retina. The maximum diameter of pupils changes with age, ranging from about 7mm for young people and declining to about 5mm by the age of forty. Therefore, binoculars with exit pupils ranging from 5 to 7mm are good choices.

Magnification is less important than the diameter of the exit pupil. For astrophotography purposes, magnifications of 7x and 8x are recommended. Although astronomical binoculars with magnifications up to 30x are available, it is very difficult to hold steady any binocular with a magnification higher than 10x.

Eye relief, or the distance from the point of focus to the rear lens element, is important if you wear eyeglasses. Normal eye relief for binoculars ranges from 9 to 13mm. However, the eye relief for people who wear glasses should be 14mm or longer. Manufacturers of better quality binoculars generally provide the eye relief in their specifications.

Binoculars vary substantially in cost and quality, but the point nature of stars demands higher quality than most terrestrial uses. A major factor in determining quality are the prisms. Some binoculars use roof prisms that have a straight-through design that is less bulky than units constructed with porro prisms. Roof prisms, although generally of high quality, are not available in as many magnifications and sizes as porro-prism binoculars and are more expensive. Porro prism binoculars are more commonly available in the sizes suitable for astronomical applications such as 7 x 35, 8 x 42, and 7 x 50. It is better to get binoculars with the more expensive BAK-4 prisms, which are sharper and transmit more light than BK-7 prisms.

. . . the point nature of stars demands higher quality than most terrestrial uses.

Security and Safety. While most astrophotographers do not encounter truly dangerous situations, any activity conducted at night and in isolated locations warrants at least minimum precautions to protect yourself. The best means of protection is to use good judgment and avoid situations with high risk. Urban parks can be unsafe places late at night, particularly when they are favored as locations for loitering by individuals and groups. The presence of other people should be taken into consideration. For example, areas frequented by recreational campers may have the same quality of sky as more isolated places but are usually safer due to the proximity of people seeking relaxation. Conversely, it would be unwise to set up in an isolated area near a gang raucously getting intoxicated.

Having companions present is always a good idea. In any case, before leaving on an outing, be sure to tell someone that you are going out and provide them with an itinerary. Make sure that your contact person knows the license plate number of your vehicle and where you will be parking.

Certain kinds of equipment make astrophotography safer and should be taken along when frequenting isolated areas. A powerful flashlight can be used to illuminate the area in the event you lose equipment or have strangers approach. Likewise, a cellular telephone can be used to summon assistance,

provided that you are within service range and know the local emergency telephone numbers. It is also a good idea to wear light-colored clothes when working in areas subject to traffic.

It is also a good idea to wear light-colored clothes. . . .

Whether to carry protective equipment such as weapons is a personal decision, but some astrophotographers feel more comfortable having some means of deterrence such as pepper spray or high-decibel alarms. However, although safety is important, one should resist paranoia. Many people are interested in astronomy and are thus attracted to astronomers and photographers in the field. Most people who approach are merely curious.

2. Basic Astronomy for Photographers

While it is not absolutely essential to know how to locate specific celestial objects to photograph the night sky, such knowledge will greatly enhance your visual awareness and enable you to make more sophisticated images. Many celestial objects are more discernable photographically than visually, and knowing how to find them and determine their relationships with other objects enables you to compose with them. For example, the Milky Way between the constellations Sagittarius and Scorpius is a rich mixture of star clouds, nebulae, and clusters that can produce magnificent images. The brightness of many of these objects is just below the visual threshold, so it helps to know how to find those constellations to compose images that show this part of the Milky Way.

The brightness of many of these objects is just below the visual threshold. . . .

The vastness of the night sky can make learning how to locate objects appear daunting, but it is not very difficult. The key to navigating the night sky is to learn a few of the most visible objects and then build on that knowledge. Finding most astronomical objects, including those that are not visible to the naked eye, becomes much easier once you know how to use a few key stars and constellations as road maps.

The Moving Sky

Earth, spinning on its axis, creates the illusion that celestial bodies move through the sky. This motion, although seemingly slow when viewed from Earth, causes objects to appear as trails on images as the exposure time increases. The easiest way to deal with this on images is to photograph using long exposures that emphasize the trails. If you want to avoid noticeable trailing, it is necessary to limit the exposure time or mount the camera on a device that rotates at the same rate as the stars.

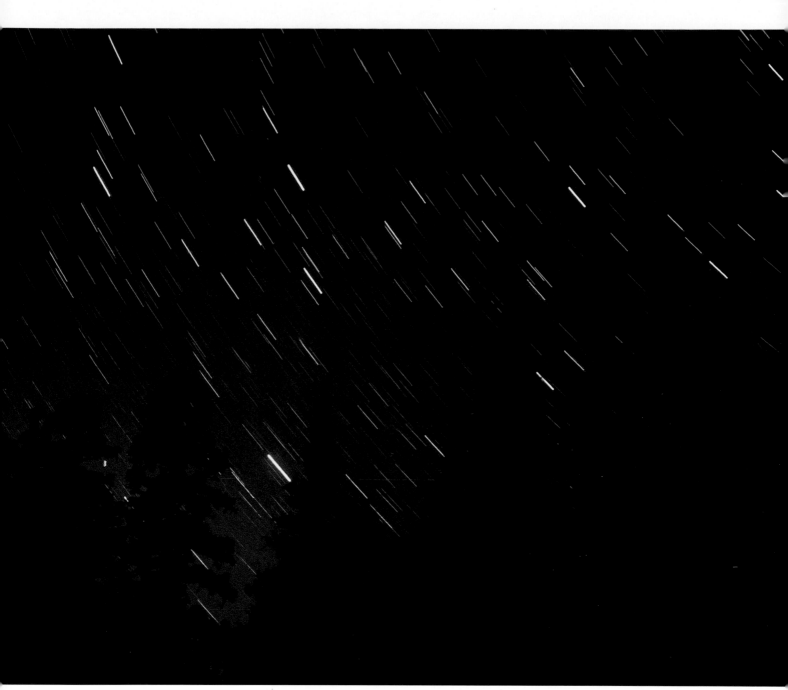

Earth's rotation causes stars to appear as trails over long exposures. Lens: 50mm. Exposure: 10 minutes at f/2.8. Film: Fuji Superia 400.

Earth's orbit around the Sun affects photography on a seasonal basis. The locations of celestial objects vary seasonally and many are visible only during certain times of the year. For example, Orion is known as a winter constellation and Cygnus is a summer constellation. The ramification is that objects are found in different parts of the sky depending on the time of night and year.

Since the location of celestial objects varies constantly, some way is needed to identify their positions at any particular moment. There are various systems for defining the locations, but all are based on units of angular distance. Angular distance is the measure of the angle between two locations. The basic unit of angular distance is the degree (°) in which a circle is divided into 360 degrees. Each degree can be further divided into sixty minutes of arc ('), and each arc-minute can be divided into sixty seconds of arc ("). For astropho-

tography, the two most useful systems of mapping the sky are the altitude-azimuth system and the equatorial coordinate system.

The altitude-azimuth system (also called the alt-az system) tells you where an object will be located in the sky from a specific place and time on Earth. This system uses two coordinates to specify the location. The azimuth angle is the angular distance along the horizon specified easterly from true north. The altitude is the angular distance measured upward from the horizon. The main advantage of this method is that it makes it possible to use simple tools such a compass and protractor to locate an object. The main disadvantage is that the information is accurate only for a specific location and even then for a brief period. Although the alt-az coordinates must be determined for specific locations and times, most astronomical software can calculate these coordinates and can print out maps showing where objects will be at any given time.

The equatorial coordinate system for locating celestial bodies is the one most commonly used by astronomers. This system is analogous to the system of longitude and latitude used to map Earth's surface but is applied to the celestial sphere. The equatorial coordinate system uses two coordinates, right ascension (R.A.) and declination (Dec.), to describe an object's location. Right ascension is the celestial equivalent of longitude except that it is divided into twenty-four one-hour segments instead of degrees. Like time, each hour segment is subdivided into sixty minutes and each minute segment is subdivided into sixty seconds. Declination is the celestial equivalent of latitude and is measured in degrees from the celestial equator. In the equatorial coordinate system, the coordinate grid rotates at the same rate as Earth. This means that the coordinates of objects do not change their respective location on the grid irrespective of the time or location of the observer. However, since the coordinate grid is constantly moving with respect to the observer, you need a sky chart to be able to find objects using the equatorial coordinate system. Although this system is not as easy to use as the alt-az system, understanding it can help refine exposure times for fixed tripod techniques and help astronomers locate difficult-to-find objects when working with a telescope. To use the equatorial coordinate system with precision, you need a device that has setting circles such as a quality telescope mount.

Deep-Sky Objects

Astronomers find it useful to distinguish between solar system objects whose movement relative to Earth varies throughout the year and deep-sky objects whose movement relative to Earth follows a constant pattern. This distinction also serves photographers well because the two classes of objects tend to require different exposures and tracking techniques. Solar system objects include the Moon, the planets, and lesser bodies such as asteroids and comets. These objects orbit around the Sun and conspicuously change their positions with respect to other objects in the sky throughout the year. Deep-sky objects are located outside the solar system and consist of bodies such as

Facing Page—The alt-az system makes it easy to find objects using a pair of coordinates. In this diagram, Saturn can be found toward the east at about 82 degrees from true north and about 26 degrees above the horizon. Note that the coordinates will change during the night as Saturn moves toward the western horizon. (Figure drawn with Power Age Sky Simulator, authored by George Dragandjikov.)

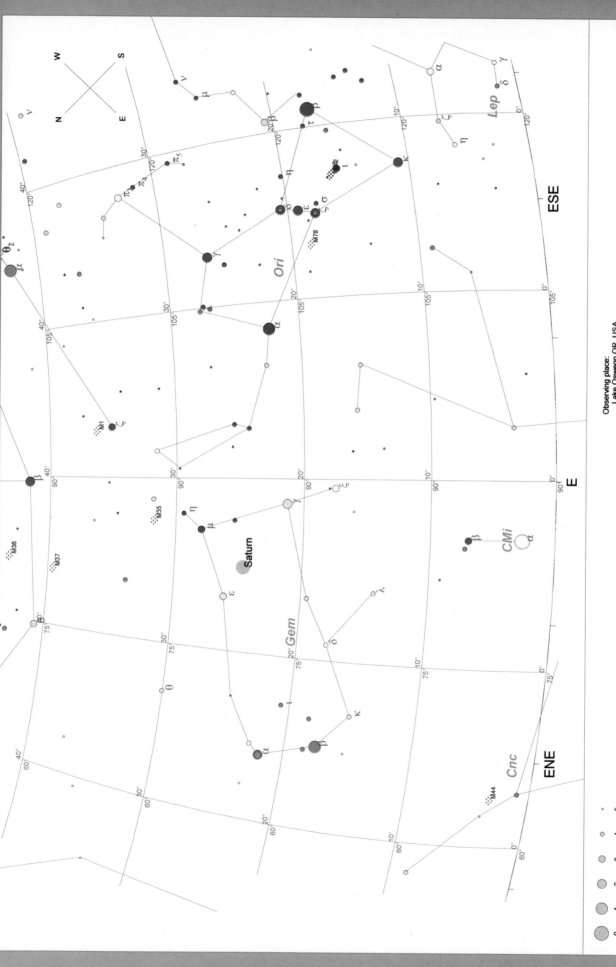

W N S

N E

ESE

E

ENE

Lep

Ori

Gem

Cnc

CMi

Saturn

M78

M35

M36
M37

M1

M44

α β γ δ ε ζ η θ ι κ λ μ ν σ τ

Observing place:
Lake Oswego,OR, USA
Latitude: 45° 25′ 11″ N , Longitude: 122° 40′ 11″ W
Date/Time:
Local: 1/1/2004 19:59:51 , DST: Yes
UT: 1/2/2004 2:59:51 Julian day: 2453006.6249

Zenith:
RA: 0h 33m 35.69s Dec: +45° 25′ 12.0″

DSO Comet

0 1 2 3 4 5

Asteroid

Target:
RA: 06h 33m 16.62s Dec: +14° 47′ 19.3″
Az: 089° 59′ 60.00″ Alt: +21° 00′ 00.0″
Zoom(vert.): 47.2°

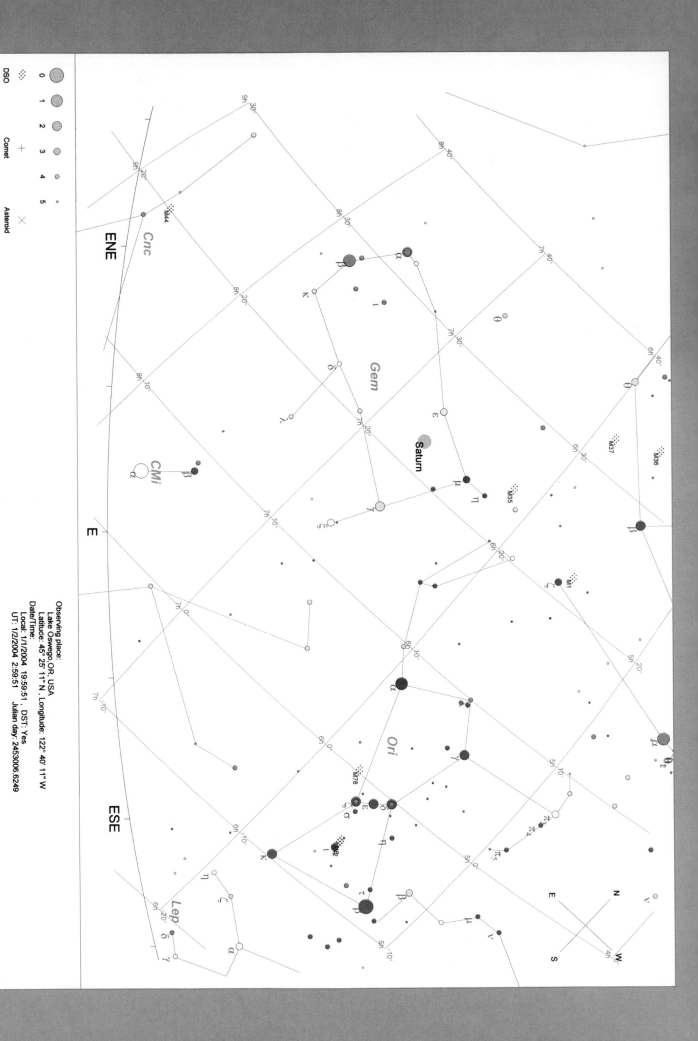

Facing Page—The equatorial coordinate system does not show an object's location relative to the viewing place. However, it has the advantage that the coordinates of deep-sky objects remain constant. In this diagram, Saturn is located at a right ascension of six hours, forty-two minutes and a declination of 24E.(Figure drawn with Power Age Sky Simulator, authored by George Dragandjikov.)

stars, nebulae, and galaxies. Because of their distance from Earth, these objects take many years before their positions in the sky change perceptibly.

The most common deep-sky objects are stars. Although human night vision does not discern colors well, from an astrophotographer's perspective, stars vary significantly in color and brightness. The hottest stars are blue or white, the medium ones are yellow, and the coolest stars are red. Film is very sensitive to star color, so it is useful to know the colors associated with various important stars. The relative brightnesses of stars are described using a magnitude scale invented by an ancient Greek astronomer named Hipparchus. The scale initially ranked stars on a scale of 1 to 6 with 1 representing the brightest and 6 representing the faintest star visible to the unaided eye. The scale has long since been extended to include brighter and dimmer stars. The Sun is a magnitude -26 star, and the next brightest star, Sirius, is a magnitude -1.4 star. The magnitudes of solar system objects such as planets vary depending on their distance from the Sun and Earth. Under very good conditions, humans can perceive stars to about magnitude 6 unaided and to about magnitude 8 with good binoculars. Film, if adequately exposed, can record much dimmer objects.

Stars most frequently exist in groups. The simplest group is the double star, in which two stars orbit around a common center. Such stars usually appear as single stars to the unaided eye but can be seen as two stars in binoculars or a telescope. Stars can also be found in clusters. An open cluster is a loose group of a few hundred to a few thousand stars, most of which are not visible to the naked eye. Globular clusters are spherical groups of hundreds of thousands to millions of stars. The largest groups of stars are galaxies, which contain billions of stars.

Nebulae are deep-sky objects composed of clouds of gas and dust. The light properties of nebulae vary depending on their composition and distance from other stars. Dark nebulae obscure otherwise visible light from distant stars and show up on photographs as dark patches in star fields. Emission nebulae fluoresce from the radiation of nearby stars and show up as red clouds in photographs, although they are gray when viewed visually. Reflection nebulae are illuminated by nearby stars and tend to photograph as blue since their dust scatters the blue portion of light more than the red. Most nebulae are diffuse and irregularly shaped, but two kinds of nebula exhibit the form of a shell. Planetary nebulae display fairly even rings caused by gases evolving off of gently erupting stars. Supernova remnants are more irregular and are created by the violent explosions of dying stars.

From ancient times, humans have grouped the stars into constellations. Even though most stars in constellations are not associated by distance or common origin, the patterns they form are used to identify areas of the sky and as tools for finding other celestial objects. For example, the Orion Nebula can be easily located because it is positioned beneath the three stars that make up the "belt" in the constellation Orion. Constellations are also used to name

individual stars. Although there are several systems for naming stars, the Bayer system is the most useful to astrophotographers because it names stars according to their constellations and order of brightness. In the Bayer system, the Greek letter "α" is assigned to the brightest star, "β" is assigned to the next brightest, and so on in accordance with the Greek alphabet. For example, the brightest star in the constellation Orion is called α-Orionis, and the brightest star in Ursa Minor is called α-Ursa Minoris.

Left—The constellation Orion features the red giant star Betelgeuse at the upper left of the hourglass. The Orion Nebula, which photographs as a vivid red, hangs in the middle of Orion's sword, located below the three stars that form Orion's belt. Lens: 50mm. Exposure: 15 seconds at f/2. Film: Fuji Velvia. **Below**—*The Pleiades, also known as Messier object M45, is an open star cluster. It can be seen immediately to the left of the lower microwave antenna. Jupiter is to the lower left of the Pleiades. Saturn is to the lower right of the Pleiades, close to the right edge of the tower. Lens: 50mm. Exposure: 10 seconds at f/2. Film: Fuji Provia 100F.*

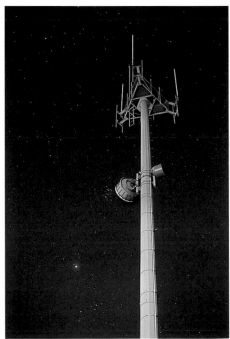

Greek Alphabet					
alpha	α	iota	ι	rho	ρ
beta	β	kappa	κ	sigma	σ
gamma	γ	lambda	λ	tau	τ
delta	δ	mu	μ	upsilon	υ
epsilon	ε	nu	ν	phi	φ
zeta	ζ	xi	ξ	chi	χ
eta	η	omicron	o	psi	ψ
theta	θ	pi	π	omega	ω

Many of the brighter stars were given common names by the Arabs and the Greeks. For example, α-Orionis is known as Betelgeuse and α-Ursa Minoris as Polaris. Knowing the most prominent stars is useful since they make it easy to identify their associated constellations.

Other deep-sky objects, such as galaxies, clusters, and nebulae, are identified differently than stars. These objects are identified by catalog numbers assigned by various astronomers and organizations. The best-known catalog was developed by Charles Messier during the eighteenth century. The Messier catalog contains 109 objects and includes many of the most notable deep-sky objects. Objects in this catalog are described by numbers such as M31, M42, and M45. Another well-known but more extensive catalog is the New General Catalog that was begun in the nineteenth century. Objects in this catalog are described with numbers such as NGC 1499 and NGC 7000. Like stars, many deep-sky objects have common names as well. Examples of the Messier objects are the Andromeda Galaxy (M31), the Orion Nebula (M42), and the Pleiades star cluster (M45). Some well-known NGC objects are the California Nebula (NGC 1499) and the North-America Nebula (NGC 7000).

Like stars, many deep-sky objects have common names as well.

Solar System Objects

The primary reason to distinguish solar system objects from deep-sky objects is that they change their position with respect to other objects throughout the year. Other than the Moon, the most prominent objects are the planets. Minor objects, such as comets, asteroids, and meteoroids, are generally less prominent, but occasionally provide the basis for good images.

The most important planets from the photographer's perspective are Venus, Jupiter, Mars, Saturn, and Mercury since they are visible to the unaided eye and record prominently on film. These planets vary in their brightness depending on their relative distances from Earth and Sun, but they are generally much brighter than stars. The outermost planets—Uranus, Neptune, and Pluto—are less visually interesting since even with magnification they appear the same as dim stars when photographed. All the planets travel in the plane of the solar system, which, when viewed from Earth, appears as a nar-

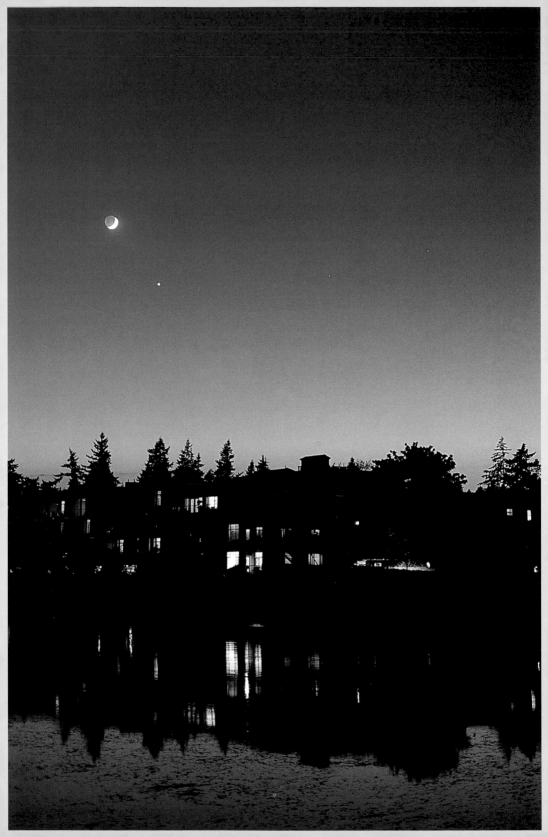

Facing Page—*The ecliptic in this photograph is plotted by two planets and the Moon. Mercury is just above the clerestory of the condominium building; Venus is the bright object diagonally upward to the left, followed by the Moon. The two stars to the right of Venus are Hamal (α-Arietis) and Mirach (β-Andromedae). Lens: 50mm. Exposure: 4 seconds at f/2.8. Film: Fuji Provia 100F.*

row belt known as the ecliptic. The Sun and Moon also reside along the ecliptic. Since the constellations of the zodiac are on or very close to the ecliptic, the Moon and planets appear to travel through the zodiac.

Comets can be very interesting photographic subjects. Composed of frozen gases and dust, comets release a visible tail when they pass close to the Sun. Most comets have orbits that extend beyond the orbit of Pluto and take thousands of years to complete. The more famous short- and intermediate-period comets have smaller orbits and have been sufficiently studied to enable astronomers to predict their return dates. Since most comets have not been studied enough to be predictable, it is not unusual to have one or more reasonably significant comets unexpectedly become visible during the course of a year. Although most of these comets are not spectacular, they can be recorded on film.

Asteroids are small, rocky bodies that are also called minor planets. Most orbit the Sun in a belt between Mars and Jupiter. Although asteroids can be photographed as trails in tracked telescope images, they are not especially interesting subjects for images. Meteoroids are objects in interplanetary space that are too small to be called asteroids or comets. They become relevant as photographic subjects when they enter Earth's atmosphere and burn up. The light emitted by these events is called a meteor. Most meteoroids are completely vaporized after hitting the atmosphere. Should a portion of the meteoroid reach Earth's surface, it is called a meteorite.

Although meteors occur sporadically throughout the night, there are a few times each year when the number observed greatly increases. These events, called meteor showers, happen when Earth passes through a debris trail left

Meteor Shower Events

Approximate Date	Name	Typical Rate	Radiant
Jan. 4	Quadrantids	40 per hour	Bootes
May 4	Eta Aquarids	20 per hour	Aquarius
July 28	Delta Aquarids	20 per hour	Aquarius
Aug. 12	Perseids	50 per hour	Perseus
Oct. 21	Orionids	25 per hour	Orion and Gemini
Nov. 17	Leonids	15 per hour	Leo
Dec. 13	Geminids	50 per hour	Gemini

by a passing comet. Each year as Earth crosses that comet's orbital path, it passes through the debris trail and we see the meteor shower. The best time to begin observing meteor showers is at midnight when the leading edge of the atmosphere spins into the debris trail. Meteor showers are named for the constellation that contains the point in the sky from where the meteors appear to originate (also called the radiant). For example, the radiant for the Perseids meteor shower is located within the constellation Perseus. The most significant meteor showers are listed above.

Left—The Big Dipper is the northern hemisphere's most recognizable asterism. If you don't recognize it, note that the bowl is made up by the four bright stars that surround the beer bottle. The three bright stars that make up the handle extend toward the upper left. The middle star in the handle is actually a double star, Mizar and Alcor. Lens: 50mm. Exposure: 15 seconds at f/2.8 with flash to illuminate the bottle. Film: Fuji Provia 100F. **Below**—The two stars that form the end of the bowl of the Big Dipper point toward Polaris, the North Star. Lens: 24mm. Exposure: 20 seconds at f/4. Film: Konica Centuria 800.

Achieving proficiency at finding constellations, deep-sky objects, and planets takes some effort but is not nearly as daunting as many people assume. However, despite what many astronomy books imply, it is rarely as simple as holding a star map and looking up. Part of the reason why amateur observing has become more difficult is that light pollution tends to obscure some of the dimmer stars that are useful for identifying constellations. When starting out, it can be frustrating when the sky as you see it bears little resemblance to your star map. However, this should not be cause for discouragement. By referencing from easily recognized objects, you can gain sufficient experience to navigate through the sky irrespective of local conditions.

The best time to view constellations is between ninety minutes after sunset and ninety minutes before sunrise. Depending on sky conditions, you may be able to see all the stars shown on a star map or only a few. Light pollution and a bright Moon will significantly reduce the number of visible stars. If you live in an urban area, it may be worth driving at least one hour outside the metropolitan area to find better skies. Pick a spot that is shielded from lights and allow your eyes to adjust to darkness for a few minutes.

As stated earlier, the constellations form the basic reference for locating objects in the sky. Although there are eighty-eight constellations distributed throughout both hemispheres, it is only necessary to be able to identify the most prominent since many have little utility with respect to locating other objects and are of little photographic interest. For photographic purposes, the prominent constellations can be divided into three types: (1) the signpost constellations that are easily recognized and point toward other constellations and objects, (2) the Milky Way constellations that delineate the most star rich portions of the sky, and (3) the ecliptic constellations that straddle the line near which the Sun, the Moon, and planets can be found.

Signpost constellations contain prominent asterisms that point in the direction of other constellations and objects. When used in conjunction with other bright stars, they are the best tools to begin learning about the night sky. Once you can recognize a few signpost constellations, it becomes fairly easy to locate others based on their proximity and direction.

The widely recognized Big Dipper asterism in Ursa Major is one of the most useful signposts. Most people can find the Big Dipper with little difficulty. In case you cannot, try looking at the northeast to northwest part of the sky at the beginning of the evening for seven stars that form the pattern of a ladle. Once you locate the Big Dipper, it is easy to find Polaris (the North Star) by following the imaginary line formed by the two stars that make up the end of the bowl of the Big Dipper and continuing five times as far as the distance between them. Since Polaris is the star at the end of Ursa Minor (the Little Dipper), you have located that constellation as well. Most of the stars in Ursa Minor are quite dim, but if you look carefully you should be able to discern the two that make up the end of the bowl.

The constellations form the basic reference for locating objects in the sky.

Top—Cygnus is a prominent constellation of Summer. The five bright stars that make up the cross are easily discerned in a photograph taken while the Moon was in the gibbous phase. Lens: 50mm. Exposure: 10 seconds at f/2. Film: Kodak E100SW. **Below**—*Cygnus taken in a dark sky with fast film. The Milky Way constellations can be overwhelmed photographically by the numerous minor stars that make up the Milky Way. Lens: 50mm. Exposure: 15 seconds at f/2. Film: Konica Centuria 800.*

The other two stars in the bowl of the Big Dipper also point to constellations. Extending an imaginary line from these two stars down below the bowl will point in the general direction of Regulus, the brightest star in Leo. Leo is an important constellation because it straddles the ecliptic and contains the radiant of the Leonid meteor shower. In the other direction, pointing above the bowl, the line runs to the bright star Deneb. This star is at the tail of the summer constellation Cygnus (the swan). Cygnus looks like a cross and is one of the Milky Way constellations.

Extending the curve formed by the handle of the Big Dipper leads to the bright ginger-colored star Arcturus in Boötes. Extending beyond the edge of the photograph will lead to bright white Spica in Virgo. Lens: 24mm. Exposure: 20 seconds at f/4. Film. Konica Centuria 800.

The handle of the Big Dipper also points to important stars and constellations. If you draw an imaginary line along the handle of the Big Dipper and continue the arc across the sky it will lead to the bright star Arcturus in the constellation Boötes. If you continue the arc further, it will extend to the bright star Spica in Virgo. If you extend imaginary lines from any of the stars in the handle of the Big Dipper through Polaris at an equal distance opposite the Big Dipper, they will intersect with Cassiopeia, which is shaped like a "W."

The handle of the Big Dipper also points to important stars and constellations.

Ursa Major is a circumpolar constellation, meaning it is visible throughout the entire year in the northern latitudes. Some important constellations are only visible seasonally. During the summer, Cygnus forms a cross, the longer arm of which points to Scorpius, which is low near the horizon. A bright red star, Antares, is located in the "J" of Scorpio. Sagittarius is the teapot-shaped constellation to the east of Scorpius. Also, the bright star Deneb in Cygnus forms the "Summer Triangle" with Vega in the constellation Lyra, and Altair in the constellation Aquila.

Name	Genitive	Abbreviation	Importance
Andromeda	Andromedae	And	Contains the Andromeda Galaxy.
Cassiopeia	Cassiopeiae	Cas	"W" points to Andromeda Galaxy and marks Milky Way.
Cygnus	Cygni	Cyg	Forms the "Northern Cross" and marks Milky Way.
Gemini	Geminorium	Gem	Contains the "twins" Castor and Pollux.
Leo	Leonis	Leo	Bright star Regulus, radiant for Leonid meteor shower.
Lyra	Lyrae	Lyr	Bright star Vega, contains M57 Ring Nebula.
Orion	Orionis	Ori	Distinctive hourglass shape, points to Pleiades.
Sagittarius	Sagittarius	Sgr	"Teapot" asterism, marks rich area of Milky Way.
Scorpius	Scorpii	Sco	Bold constellation, marks rich area of Milky Way.
Ursa Major	Ursa Majoris	UMa	Contains "Big Dipper" Asterism, points to Polaris.
Ursa Minor	Ursa Minoris	UMi	Contains Polaris (the North Star).

A Few Good Stars

Name	Importance
Sirius (-1.4)	The brightest star, in constellation Canis Major. East of Orion.
Arcturus (0.0)	Bright star in Boötes. Forms middle of curve extending from handle of Big Dipper to Spica.
Vega (0.0), Altair (0.8), and Deneb (1.3)	Form the "Summer Triangle." Vega in Lyra is near the Ring Nebula. Deneb is at the tail of Cygnus and near the North-America Nebula.
Betelgeuse (0.5)	Prominent red star forms northeast corner of Orion hourglass.
Rigel (0.1)	Prominent blue-white star forms southwest corner of Orion hourglass.
Aldebaran (0.9)	Bright star in Taurus.
Antares (1.0)	Bright star in Scorpius.
Spica (1.0)	Bright star in Virgo.
Pollux (1.1) and Castor (1.6)	The twins in Gemini.
Regulus (1.4)	Bright star in Leo.
Polaris (2.1)	The North Star.

Aldebaran, to the right, is a bright red star that marks the mostly faint Taurus. The bright yellow object to the left is Saturn. Lens: 50mm. Exposure: 10 seconds at f/2. Film: Kodak E100SW.

Under good conditions, the Milky Way looks like a faint cloud.

An important constellation of winter is Orion, which has four bright stars that form an hourglass figure with a belt of three stars at the middle. This constellation can be found after sunset in the southeastern part of the sky in late autumn and in the southern part of the sky in winter. If the line formed by the belt is extended to the west, it points toward Aldebaran, which is a very bright star in the constellation Taurus. Extending the line somewhat further points toward the Pleiades, an open star cluster also in Taurus. Extending the line formed by the northeast corner and southwest corners of the hourglass points to Castor and Pollux in Gemini.

The Milky Way is important photographically because of its rich star fields. Under good conditions, the Milky Way looks like a faint cloud. Unfortunately, the Milky Way is one of the most vulnerable victims of light pollution. In the summer, the Milky Way follows the path indicated by Cassiopeia and Cygnus, and falls between Sagittarius and Scorpius. In winter, the Milky Way follows a line running from Cassiopeia and to the east of Orion.

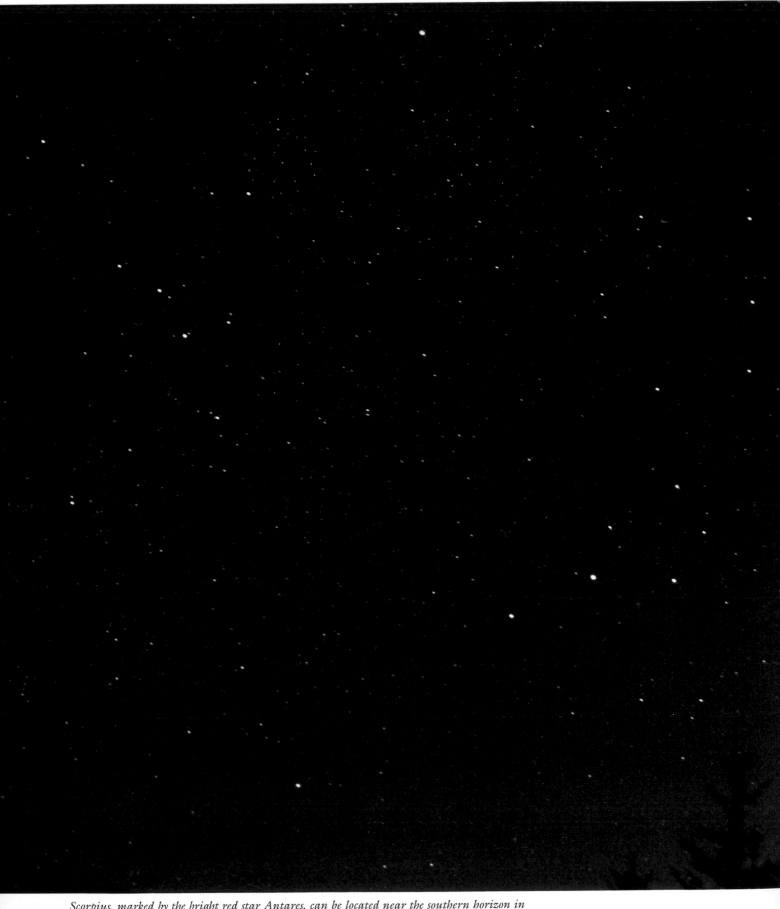

Scorpius, marked by the bright red star Antares, can be located near the southern horizon in summer. Lens: 50mm. Exposure: 120 seconds (guided) at f/2.8. Film: Konica Centuria 800.

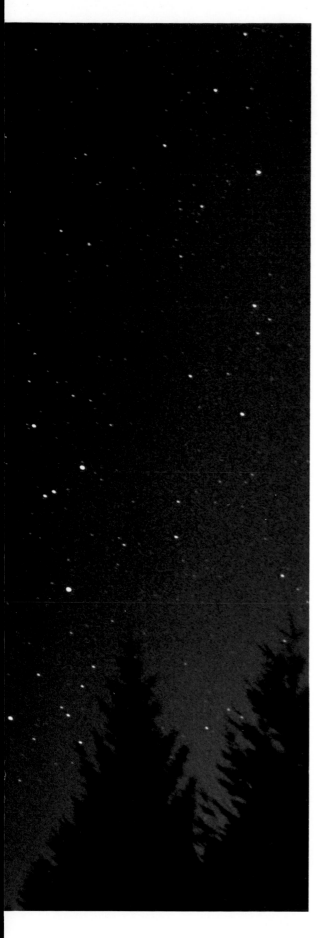

There are twenty-one constellations that the planets (excluding Pluto) can pass through, which is a larger set than the traditional twelve constellations of the Zodiac. Thirteen constellations actually cross the ecliptic and constitute the constellations where the Moon and planets are found most often. Some of these constellations are quite prominent but many are inconspicuous. What makes these constellations useful is that they can be used to find the planets. For example, if you know that Jupiter is in Gemini, then it is a simple matter to find Jupiter by looking at Gemini. Conversely, prominent objects such as the Moon and Venus can be used to locate constellations. If you know that the Moon is in Aries, you can find Aries by looking for the Moon. The thirteen ecliptic constellations, with the most prominent set in , are found in the chart located on the following page.

Once you can identify some key stars and constellations, it is a relatively straightforward process to find others. For example, the constellation Hercules is located about halfway between Vega and Altair, and Cancer can be found between Gemini and Leo. Remember to consider the effect that sky conditions will have on the ability to discern constellations. For example, the constellations Capricornis and Aquarius contain dim stars and may be invisible to the unaided eye, even in moderately polluted skies.

A good foundation with regard to identifying constellations makes it simpler to locate deep-sky objects. For an easy-to-find double star, note that Mizar and Alcor form the "star" that is second from the end of the handle of the Big Dipper. People with very good vision can resolve the double without aids, although most people require binoculars. A good 50mm lens will have no difficulty resolving this double. The Orion Nebula is easy to find and one of the few nebulae that can be seen unaided. Follow the stars down from the east end of Orion's belt. The nebula is the smudge at the end of "Orion's sword." It looks gray when viewed visually but appears red in photographs. The larger half of the "W" that forms Cassiopeia points toward the Andromeda galaxy. This galaxy may be discerned visually as a small smudge when sky conditions are very good.

Building proficiency will require you to get a decent guide to the locations of deep-sky objects and the planets. Fortunately, many kinds of references are available. Star maps in periodicals such as *Sky and Telescope* magazine are convenient to use in the field and provide current information on the locations of the Moon and planets. Star atlases are collections of maps that provide excellent detail but are usually geared to more advanced users. Planispheres are a type of star map that can be adjusted to show the locations of

stars by date and time. They are convenient to use but show less information than maps and atlases. On the other hand, some atlases show too much information for beginning astrophotographers. These atlases are intended for advanced telescope astronomers and include many objects that are impossible to discern without large telescopes. A few guides use photographs instead of charts. While some show sufficient restraint, others rely on densely exposed images in which a multitude of stars not visible to the naked eye obscure the view of the depicted constellations. These are very difficult to use and are not recommended.

Astronomical software provides another option for making star maps. One advantage to using such programs is that you can tailor maps to show the sky at specific observing locations, dates, and times. To use these programs, you enter your location and the time that you will be viewing. Some of the better programs allow you to specify a limiting magnitude to adjust for sky conditions. For example, if you are viewing from an urban area where only stars of magnitude 3.5 or brighter are visible, the software can omit faint stars that will not be visible. Another useful feature is the ability to obtain the azimuth-altitude coordinates, which are generally a better way to locate objects when you are not using setting circles.

Planning Images

The constantly changing nature of the night sky makes it imperative to be able to visualize images ahead of time if you are to maximize your shooting opportunities. Fortunately, most of the work involved in finding a site and planning for an image can be done ahead of time. Using aids such as maps, compass, and protractor, it is possible to plan images with a great deal of precision.

The first step in planning an image is to find a location and subject that appeal to you. For example, if you want to make a photograph that incorporates a river and a particular constellation, you need to find suitable places from which to make the image. Not only must such places present the desired aesthetic, they must be readily accessible when you want to take the photograph. Scouting can be done during daylight hours since the timing of the conjunction between the terrestrial and the celestial subjects will be determined later using maps or a computer. In some respects, evaluating sites during daytime is highly recommended since obstructions and extraneous elements such as power lines can be difficult to detect at night. However, be sure to take note of any artificial lighting that could impair the image if turned on at night.

Once you have located a promising site, determine its latitude and longitude from a map. Traditional topographic maps such as those available from the United States Geologic Service are good, but map software designed for outdoor enthusiasts is even better. Using a global positioning system (GPS) in conjunction with map software simplifies the process of determining coor-

Once you have located a promising site, determine its latitude and longitude. . . .

Ecliptic Constellations	
Sagittarius	Cancer
Capricornus	**Leo**
Aquarius	**Virgo**
Pisces	Libra
Aries	**Scorpius**
Taurus	Ophiuchus
Gemini	

Note: The most visually prominent constellations are in boldface.

dinates, but it not very hard to determine them using traditional map and compass techniques. If you are using a compass, take several compass bearings to surrounding landmarks to ensure accuracy. In addition, make sure to apply the appropriate compass declination for your area to correct the magnetic bearing to the true bearing.

If you are using a compass, take several compass bearings. . . .

Once you have determined the latitude and longitude of the site, the next step is to determine the true bearing from the site to important landmarks, the distance between them, and the difference in altitude. This information is needed to calculate the azimuth and altitude from the site to the terrestrial subject. The azimuth is simply the true bearing between the place and the important landmarks. The altitude can be calculated by taking the arctangent of the ratio of the horizontal distance to the elevation difference, i.e.:

Altitude = arctangent (horizontal distance ÷ elevation difference)

(Most scientific calculators have an arctangent function, frequently designated as "ATAN.")

Once the azimuth and altitude to the terrestrial subject are known, the next step is to consider the possibilities for incorporating celestial objects and determining the dates and times at which images might be made. To do this, it is necessary to envision the scope of the image, which will largely be deter-

Angle of View for 35mm Lenses

Focal Length	Diagonal Angle	Vertical Angle	Horizontal Angle
20mm	94°	61°	83°
24mm	84°	53°	74°
28mm	75°	46°	66°
35mm	64°	38°	54°
50mm	46°	26°	38°
85mm	29°	16°	24°
105mm	23°	13°	20°
135mm	18°	10°	15°
200mm	12°	7°	10°
300mm	8°	5°	7°

mined by the angle of view of the lens. With a level camera, the angle of view from the level horizon is one-half of the total angle of view. The angle of view also depends on whether the camera is oriented for a vertical or horizontal composition. Make sure to account for the amount of sky covered or obscured by any objects that extend above the level horizon, such as mountains and other landscape elements. Naturally, the coverage of the sky can be increased or decreased somewhat by tilting the camera. The table above

shows the angle of view associated with the focal lengths of lenses for 35mm cameras.

Once the approximate altitude of coverage is known, you can determine which celestial objects can be included in potential images. Making this determination is where astronomical software is extremely useful, since these programs can show where celestial objects will be located in the sky at any given time and place. Each program has its own procedures, but most allow you to enter the latitude and longitude of the viewpoint and then display the celestial objects that will be within the azimuths and altitudes covered by the desired lens. By experimenting with various times, dates, and angle of views, you can usually find good photographic scenarios.

People who are unfamiliar with navigation or trigonometry may find this process intimidating, but it is not that difficult. The process and calculations that went into the planning of an actual image are shown in the following example.

Case Study: Mt. Hood and the Leonid Meteor Shower Adventure

Mt. Hood is the highest peak in Oregon and a frequently photographed landmark. One of the best views of Mt. Hood can be reached by hiking about 1¼ miles along a trail on Bald Mountain. This viewpoint has an unobstructed view of Mt. Hood and is less than five miles from its peak. To assess the possibilities for night images, I needed to determine the azimuth and altitude of Mt. Hood's peak as seen from the viewpoint. To do this, I found the viewpoint and Mt. Hood on a topographic map and then recorded the following information:

Bearing from Viewpoint to Mt. Hood: 120°
Distance between Viewpoint and Mt. Hood: 4.56 miles
Elevation Difference: 11,130 ft. – 4,270 ft. = 6,860 ft.
Longitude of Viewpoint: 121° 46' 19"W
Latitude of Viewpoint: 45° 24' 12"N

The azimuth from the viewpoint to Mt. Hood is the same as the bearing, which is 120 degrees. The altitude from the viewpoint to the summit of Mt. Hood was calculated as follows:

Altitude = arctangent [6,860ft. ÷ (4.56 miles x 5,280 ft. per mile)] = 15.9°

A 50mm lens, oriented for a vertical shot and tilted slightly upward, would comfortably encompass most of the mountain and about 20 degrees of sky. Similarly, a 24mm lens oriented for a horizontal shot would capture a panoramic view of the mountain and about 30 degrees of sky.

Clearly there was potential for an interesting photograph. The question was what to photograph and when. Since Mt. Hood is located southeast of

Facing Page—A chart was plotted showing Mt. Hood relative to the Bald Mountain viewpoint for early morning during the Leonid meteor shower. (Figure drawn with Power Age Sky Simulator, authored by George Dragandjikov.)

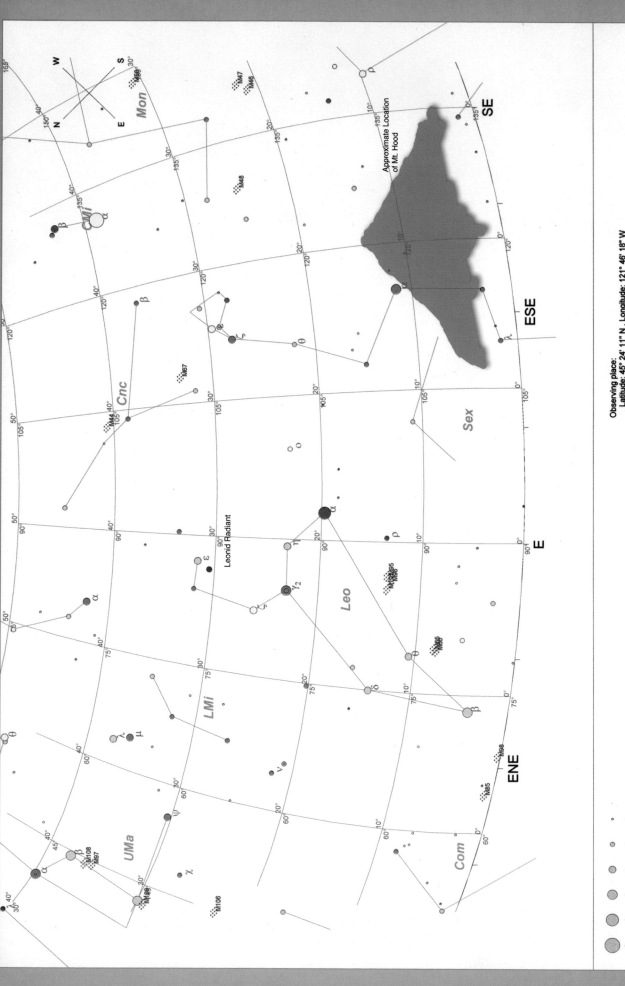

Observing place:
Latitude: 45° 24' 11" N , Longitude: 121° 46' 18" W
Date/Time:
Local: 11/18/2001 1:29:50 , DST: No
UT: 11/18/2001 9:29:50 Julian day: 2452231.8957

Zenith:
RA: 05h 12m 43.94s Dec: +45° 24' 12.0"

Target:
RA: 09h 53m 22.20s Dec: +12° 06' 28.7"
Az: 095° 31' 44.95" Alt: +22° 28' 47.3"
Zoom(vert.): 60.0°

DSO Comet Asteroid

0 1 2 3 4 5

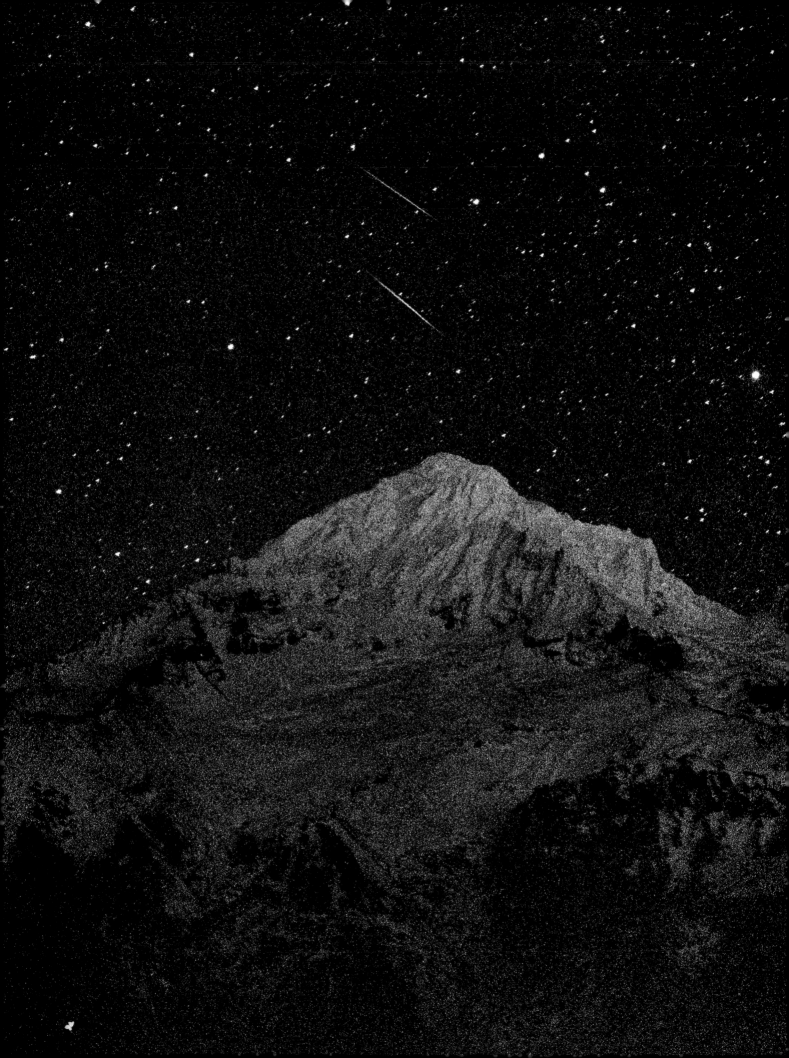

Facing Page—*Images don't just happen. Prior planning resulted in photographing a pair of meteors over Mount Hood. Lens: 50mm. Exposure: About 15 seconds at f/2. Film. Kodak TMAX3200 exposed at EI 3200.*

Some Recommended Star Guides

Find the Constellations, by H. A. Rey (Houghton Mifflin Company, 1976).
A simple approach to learning constellations that is published as a children's book. The maps show stars with and without lines connecting the stars in each constellation.

Summer Stargazing, by Terence Dickinson (Firefly Books, Ltd., 1996).
Constellations are superimposed on wide-field photographs. Provides a good introduction to the planets and deep-sky objects.

Cambridge Star Atlas, 3rd Ed., by Wil Tirion (Cambridge University Press, 2001).
Contains maps that show stars and objects that are visible with small optics and binoculars.

Norton's Star Atlas and Reference Handbook, by Arthur P. Norton and Ian Ridpath (Addison-Wesley, 1998).
A revised classic with maps showing objects that are visible with small optics.

Turn Left at Orion, 3rd Ed., by Guy Consolmagno and Dan M. Davis (Cambridge University Press, 2000).
Excellent book for finding deep-sky objects with a small telescope.

the viewpoint, the candidates for celestial objects for the image need to appear within the window of coverage during night sky conditions. Various candidates were evaluated by using astronomical software to ascertain which objects would appear in the image windows between ninety minutes after sunset and ninety minutes before sunrise. This was fairly easy to do by entering the longitude, latitude, and prospective dates into the computer and printing the corresponding star maps.

The nice thing about meteor showers is they reliably occur on the same days each year and emanate from the same spot in the sky. The Leonid meteor shower reaches its peak during the very early hours of November 18 and emanates from the constellation Leo. Punching in the data showed that the radiant in Leo would rise from 20 to 40 degrees altitude and slew from 45 to 20 degrees north of Mt. Hood between 1:30AM and 3:30AM. Since meteors photograph best when about 30 to 45 degrees from the radiant, this would be the perfect time and place to photograph meteors near Mt. Hood.

The next part was planning the trip. I had no trouble convincing a friend, Darryl Stewart, that this would be an interesting outing if the weather was clear. There were clouds on the morning of November 17, 2001 but they gradually cleared throughout the day. We arrived at the trail head at 10:00PM and rested in sleeping bags until 1:00AM. During the hike to the viewpoint, Darryl mentioned that he doubted there would be cougars present since there were not many deer in the area for them to eat. I expressed my concern that the lack of deer might make the cougars less finicky about what they ate.

Anyway, cougars or not, we arrived safely at the viewpoint at about 1:30AM and set up our gear. I set up a tripod for star trails with a 24mm lens and actively worked a camera on another tripod with 50mm and 135mm lenses. We took photographs for the next two hours and then hiked back to the car. The 2001 Leonids went down as one of the legendary showers and the view from Bald Mountain was of the highest quality. Hiking in the middle of the night is not something that most people do casually. By planning, we were able to spot a great opportunity ahead of time and act on it.

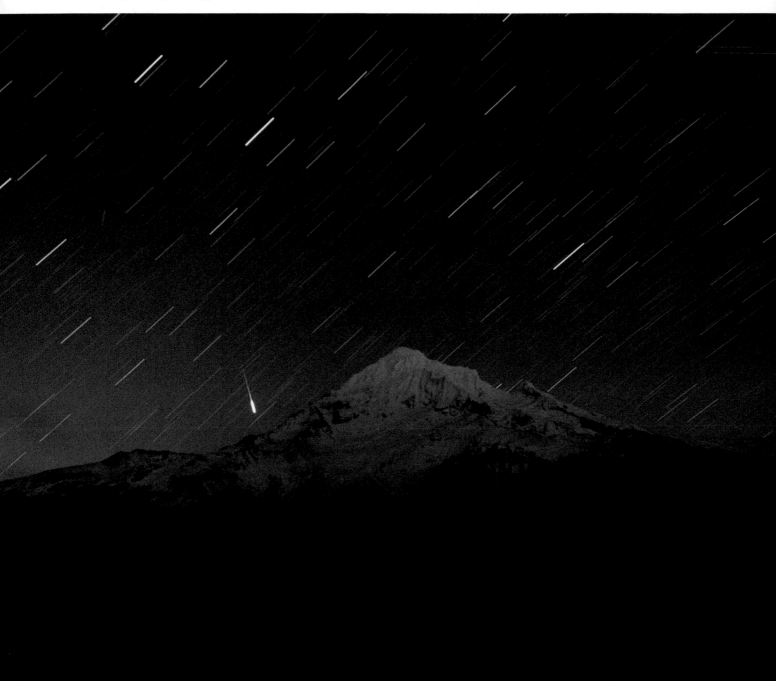

One camera was set for long-exposure star trails while the other was actively worked for exposures of ten to fifteen seconds. Immediately after this fireball lit up the sky, the exposure on the star trail camera was ended. Lens: 24mm. Exposure: about 30 minutes at f/4. Film: Fuji Superia 400.

3. Exposing the Night Sky

Films are intermittently modified and often without notice to the public.

One of the exciting developments during the last ten years or so has been the introduction of films that are fast, low grain, and sensitive to the wavelengths important to astrophotographers. These films have greatly simplified high quality astrophotography for amateurs. The availability of films that can be used straight from the box means that astrophotographers no longer have to use gas-hypersensitized films or special cold cameras to produce high quality images. The only problem with the new generation of films is that they are designed for purposes such as sports photography and photojournalism. Since manufacturers feel little to no incentive to make films specifically for astrophotography, there is no ideal film—although there are several very good ones. Unfortunately, films are intermittently modified and often without notice to the public. Since the films are changed to improve their characteristics for conventional photography, the modified versions are not always as good for astrophotography. This puts the burden on astrophotographers to know what film properties they need and how to evaluate how well particular films meet their needs.

Film

Basic Concepts of Exposure. Reduced to its bare essentials, exposing film is no more than controlling the amount of light that reaches the film during the exposure. The two means photographers have to control exposure are changing the exposure time and altering the rate of light transmission through the lens. Exposure times are adjusted by setting the shutter speed. For example, an exposure time of eight seconds allows twice as much light to reach the film as an exposure time of four seconds. The rate of light transmission is most commonly controlled by closing the lens diaphragm to reduce the effective aperture of the lens. For each f-stop that the lens is closed down, the rate of

light transmission is cut in half. For specialized applications such as solar photography, the rate of light transmission is also controlled by using filters.

In the exposure ranges most commonly used in conventional photography, the density of the image formed on the film will vary proportionately with the degree of exposure. For example, doubling the exposure time or opening up the lens diaphragm by one f-stop will cause the density of the image on the film to increase accordingly. This is known as the reciprocity relationship in which the amount of light needed to expose the film to a specific density remains constant within a certain range of exposure values. However, films are less efficient at recording very low levels of light and no longer follow the reciprocal relationship when long exposure times are used. This is known as reciprocity failure. For example, doubling the exposure from two minutes to

A practical way to assess a film's sensitivity to the important red alpha-hydrogen emission line is to photograph the constellation Orion. The Orion Nebula should appear strongly crimson. Lens: 50mm. Exposure: 15 seconds at f/2. Film: Provia 100F.

four minutes will not result in the same intensity of effect as doubling the exposure time from $\frac{1}{250}$ second to $\frac{1}{125}$ second. Since reciprocity failure occurs at low levels of light, exposure times must be extended even longer to compensate for the film's reduced efficiency at recording light. Print films tend to start showing reciprocity failure at exposures greater than one second. A few slide films do not show reciprocity failure until the exposure time exceeds two minutes.

Performance Considerations in Selecting Film. The major considerations in selecting film for astrophotography are film speed and color sensitivity. Film speed is important since it determines how long an exposure must be to record sufficient detail in the images. Color sensitivity is important since some celestial objects, particularly emission nebulae, emit light in specific wavelengths. If a film is not sensitive to that particular wavelength, much of the object will not be recorded in the image.

A film's speed is represented by its ISO number. When classifying films by speed, films with IS0 ratings of less than 100 are considered slow, films between 100 and 200 medium, between 250 to 800 fast, and above 800 superfast. As a general rule, faster films have more grain and show less detail than slower films. However, since films vary in their susceptibility to reciprocity failure, a faster film will not necessarily perform better than a slower film during long exposures.

There are methods that can be used to reduce reciprocity failure; however, they are largely beyond the scope of this book. Some advanced astrophotographers use gas-hypersensitized ("hypered") films, which are dried by placing them in a closed chamber in the presence of a gas such as hydrogen. Hypering reduces reciprocity failure and sometimes improves color sensitivity. The preparation of hypered film requires a substantial investment in special equipment. Cold cameras are another method used to increase film speed. These cameras use dry ice to supercool the film, which enhances the sensitivity to light. Although hypering remains popular with astrophotographers, few still use cold cameras. Many astrophotographers use stock films, since there are several modern emulsions that do not require any special processing or modification to perform well for astrophotography.

The color sensitivity of a film can be a critical factor in astrophotography, depending on the subject matter. The most important color in astrophotography is red since the fluorescing hydrogen gas in emission nebulae emits red light at a specific spectrum known as the alpha-hydrogen emission line. If a film is not sensitive to this wavelength, it will not record nebulosity very well. Blue sensitivity is important when photographing reflection nebulae and comets, since these objects scatter blue light more than red. Objects such as galaxies and star fields benefit from film with good sensitivity to yellow.

A good way to assess a film's potential suitability for astrophotography is to compare the spectral sensitivity curve in the manufacturer's data sheet with the curve of a film known to be good for astrophotography. It is particularly

There are methods that can be used to reduce reciprocity failure.

important to assess the spectral sensitivity at the alpha-hydrogen emission line, 656 nanometers. Even if a film appears promising, it still requires testing to assess its performance during long exposures. For example, Ilford's SFX has extended red sensitivity but performs poorly as an astrophotography film because it suffers from severe reciprocity failure.

Other Considerations in Selecting Film. Slide and print films are both suitable for astrophotography although there are advantages and disadvantages to each. One important consideration is the practicality of processing the images. Slide film has the advantage that the final image is determined by the exposure and in-camera composition. Once the film is developed, no further processing is required. This means that you do not run the risk that sloppy printing will produce disappointing images. In addition, slide films tend to have better reciprocity characteristics than negative films and, overall, cost less to buy and process.

Despite their lack of sensitivity to red, conventional black & white films can be used for astrophotography if nebulae are not important to the image. The tack-sharp star trails in this exposure contrast with the blurred images of cottonwood trees in a windstorm. Lens: 50mm. Exposure: 90 minutes at f/5.6. Film: Ilford Pan F+.

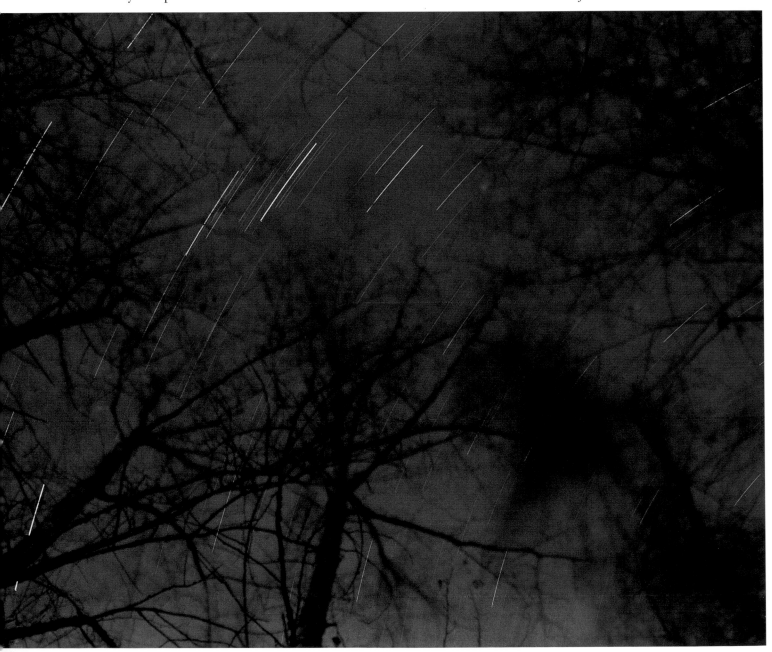

Print films produce a negative that must be printed before the image can be easily viewed. The main advantage of print films over slide films is that they have a broader exposure latitude. This makes it easier to obtain a decent print—even if the exposure time was too long or short. In addition, fast negative films produce better quality images than fast slide films. However, astrophotography images require special attention to print, which means that automated mini-labs tend to produce disappointing results. Using slide film can be the most feasible means of controlling your images if you do not have access to your own printing equipment and want to avoid the expense of custom printing.

Most astrophotographers use color films with good red sensitivity. The only black & white emulsion that has good red sensitivity and reciprocity characteristics is Kodak Technical Pan. Since this film must be gas-hypersensitized to be suitable for astrophotography, it is used mostly by advanced astrophotographers. This does not mean that conventional black & white emulsions cannot be used for astrophotography. While they do not record emission nebulae well, they excel at imaging monochromatic subjects such as the Sun and Moon. They are also highly suitable for artistic and landscape photographs that incorporate celestial elements.

Making the Selection. It would be nice to be able to recommend specific films for astrophotography, but manufacturers change their emulsions so frequently it is impossible to be assured that any particular film will remain suitable over a sustained time. To complicate matters, manufacturers sometimes change emulsions for a particular film without informing customers. For example, Kodak Royal Gold 400 might be a good film one year, then be modified into a bad film the next. Spectral sensitivity charts in film data sheets provide useful information that can be used to screen promising films. Testing the emulsion in the field will confirm which ones are suitable. Talking to other astrophotographers or looking for information on the Internet are other ways to find out which films are the current best performers. It is also good to experiment with a variety of films to find the ones that suit your personal tastes.

Testing the emulsion in the field will confirm which ones are suitable.

Exposure

Dealing with Sky Fog. Sky fog is the washing out of the background of an image caused by the film recording the brightness of the sky. The night sky has a natural brightness caused by air glow, starlight, atmospheric scatter, and interplanetary dust. Given a long enough exposure, this brightness begins to wash out the fainter objects in an image. The susceptibility of an image to sky fog is strongly affected by the focal ratio of the lens used to make the exposure since the focal ratio controls the ability to record area sources of light.

Setting a lens at a higher f-stop (i.e., increasing the focal ratio) will reduce the effect of sky fog but will also reduce the effective aperture of the lens and thus make it less efficient at recording stars. The overall effect is a sparser field

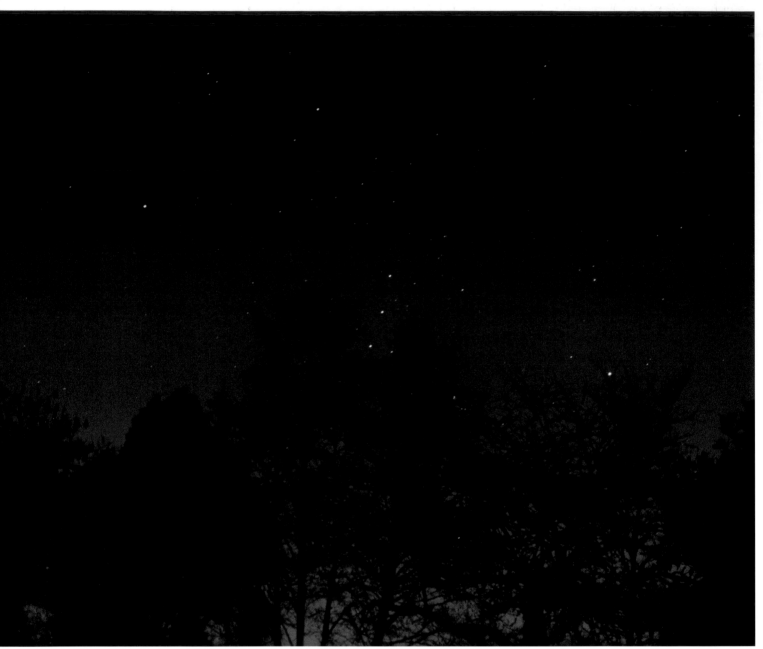

of stars with a better background. This approach, along with filtration techniques described later in the chapter, works well to limit the effect of sky fog for some kinds of images depending on the effect you want. However, the most common approach to dealing with sky fog is to determine by trial and error the maximum exposure times that are possible under particular sky conditions before sky fog degrades the image.

Images made with wide-angle lenses will suffer more from sky fog than images made with lenses with longer focal lengths when used at the same f-stop and exposure time. The reason is that a wide angle lens used at a low focal ratio will be relatively efficient at recording background light but relatively inefficient at recording stars due to the small aperture inherent with these lenses. Conversely, telephoto lenses produce more contrasty images given the same f-stop since their larger physical apertures enable them to record stars more efficiently than the background. This does not mean that

Although light pollution from artificial sources is something mostly to be avoided, it can occasionally be used to obtain specific effects such as the red background in this image of Orion rising above a row of trees. For the most part, however, light pollution has become a pervasive scourge and can no longer be ignored.

wide-angle lenses cannot be used successfully for astrophotography or that telephoto lenses produce better images. However, photographers should be aware that the maximum times to avoid sky fog will be less for wide-angle lenses than for telephoto lenses.

In addition to the sky's natural brightness, the Sun and Moon also contribute to sky fog. Even after the Sun sets, it continues to illuminate part of the sky during twilight. Similarly, the Sun illuminates part of the sky before sunrise during dawn. To avoid the influence of the Sun, it is best to limit night astrophotography to the period between ninety minutes after sunset and ninety minutes before sunrise. The Moon has a significant effect on the night sky depending on its phase. During the period four days before and after the Full Moon, it is very bright and will wash out all but the brightest objects. However, conditions improve considerably before first quarter and after last quarter. As a general guideline, the Moon should have little effect when it is six days before or after the New Moon or after it has set. A good way to assess the quality of the sky is by how easily you can see the Milky Way.

Man-made illumination is the most troublesome contributor to sky fog. The main source of the problem is unshielded lights that allow much of their energy to escape upward. The resulting light pollution causes the sky to brighten and can significantly reduce your sky fog limit. For example, the sky fog limit using an 800 speed film at f/2 can be as short as fifteen seconds at an urban site but as long as ten minutes at a dark rural site. In addition to the extra fogging, the glow added by artificial lights can adversely affect images by creating undesirable color casts. The effects of light pollution on astrophotography can be reduced somewhat by filters, but the problem has become sufficiently severe that many celestial objects can only be photographed from remote sites.

Filtration. To a limited extent, filters can be used to correct for color shifts caused by reciprocity failure and to reduce sky fogging from artificial lighting. Filtration can be particularly helpful when using slide films because color shifts and fog cannot be adjusted in the final image. Print film can be affected as well, although the ability to make corrections during printing ameliorates the problem somewhat.

Film manufacturers publish data sheets that provide information on how to correct for color shifts caused by reciprocity failure. Look at the reciprocity correction tables in the data sheet for a particular film, and note which kind of filtration is recommended for longer exposures. While tables seldom address very long exposures, the direction of the color shift will indicate what kind of correction will be needed. For instance, a film that shifts toward green during a long exposure will need to be corrected with a magenta filter. Film data that show that a minor correction is needed for a relatively short exposure should be interpreted that more correction will be needed as the exposure time is extended. For example, a film that requires five units of magen-

Man-made illumination is the most troublesome contributor to sky fog.

ta at fifteen seconds may work very nicely with an FLD filter that has about thirty units for a twenty-minute exposure.

Color shifts caused by stray artificial lighting can be more difficult to deal with because the amount of filtration required will usually affect the colors of the celestial objects as well. Situations in which foreground objects are affected by stray lighting are especially difficult to correct. In such cases, it is often better to accept the color shift and hope it does not clash with the image than to attempt to correct the foreground at the expense of the background.

The major light sources encountered during astrophotography are sodium vapor, mercury vapor, metal halide, and incandescent. Mercury vapor is probably the worst light to have to deal with since it shows up on film as an unnatural blue-green cast. Incandescent lighting causes a golden cast, which can sometimes accent an image if it is not too intense. Film manufacturers usually provide guidance on what filters are needed to correct for artificial lighting in their data sheets. When the type of lighting cannot be identified, or when the lighting is mixed, an FLD filter is usually the best compromise.

Most urban and suburban skies are significantly degraded by light pollution. Since many celestial objects emit their light within a narrow portion of

Portland, Oregon is considered to be one of the more enlightened cities regarding the control of light pollution. This fifteen-second exposure was taken at 3:30AM on a moonless night from a mountain site about forty miles from the suburban edge. Clearly, more needs to be done to reduce the stray light emanating from the city.

Above—*Reciprocity failure induced this severe shift to green. Lens: 50mm. Exposure: 20 minutes at f/5.6. Film: Fuji Velvia.*
Right—*The blue-green cast on the sand was created by mercury vapor lighting. The effect perhaps could have been tolerated if light pollution had not washed out the sky. Lens: 50mm. Exposure: 10 seconds at f/2. Film: Fuji Velvia.*

the spectrum, it is possible to use filters that block the yellow and green spectrum emitted by artificial light sources such as sodium vapor lamps and pass the red and blue spectrum associated with most celestial objects. Red filters such as the Wratten #25A work well for black & white images, although they impair light transmission and will cause a red cast if used with color film. Filters are available from specialty suppliers that are suitable for color films. Examples include the Lumicon Deep Sky filter, the Orion Sky Glow filter, and the IDAS Light Pollution Suppression filter. These filters will cause some color shift but greatly improve contrast by eliminating sky fog caused by the more common types of artificial lighting. All these filters are available in 48mm filter thread and the IDAS filter is available in the other common filter threads as well. Conventional photographic filters such as FLD and di-

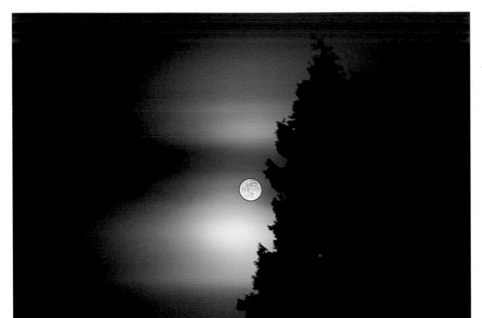

Top—*Sodium vapor lights can give clouds a brown to yellow cast.* **Bottom**—*Stray light from incandescent bulbs can sometimes enhance an image if the effect is not extreme. Lens: 50mm. 15 seconds at f/2. Film: Kodak E100SW.*

dymium (enhancing) types can also reduce sky glow from artificial lighting but generally are not as effective as filters specifically designed to suppress light pollution. However, they are available in more sizes and are usually much less expensive.

Processing. If you have your film processed commercially, it is strongly recommended that you take measures to ensure proper care and handling. First, be sure to inform the laboratory that the images taken were of stars at night. Hopefully, this will keep them from throwing away your negatives or transparencies under the mistaken impression that there are no images on them. Cutting the film into strips for storing in negative sleeves or into frames for mounting slides can be very difficult if there is no clear demarcation between the frames. One way to reduce this problem is to take at least one photograph using flash or daylight at the beginning of each roll. This produces a frame with sufficient density to permit the technician to discern the

boundaries between frames. To avoid problems with bad cutting, some photographers ask for their processed film to be returned uncut and do their own cutting or mounting. If you allow the laboratory to cut or mount your film, be sure to specify that all frames are to be sleeved or mounted. Otherwise, you run the risk that some images will be disposed because the technician thought they were blank.

Once slides are exposed and developed, there is no additional processing that can mess up the image. Negative films, on the other hand, are subject to printing errors. Your options for commercial printing are to have your images printed at a mini-lab oriented toward consumers or at a commercial laboratory that mostly does printing for professional photographers. Mini-labs use automated printers to expedite processing. These machines take entire rolls

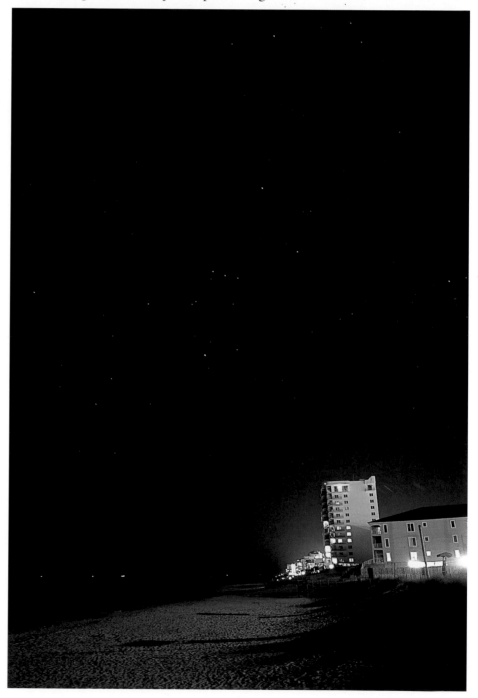

Mercury vapor lighting creates an unnatural blue-green cast on the objects it illuminates. Orion is at the center of the image. Sirius, the brightest star in the northern hemisphere, is to the left. Lens: 24mm. Exposure: 20 seconds at f/4. Film: Fuji Velvia.

of film and automatically expose and balance the color based on the first frame. Some machines use that exposure and color balance for printing the rest of the roll. Better machines may adjust exposure and color balance for individual frames. Since automated printers are designed to print conventional subjects, they often fail to expose and balance astrophotographs adequately.

Custom laboratories are capable of doing excellent work but can be frustrating as well. It can be helpful to show some examples of good images to give them an idea of how you want your prints to look. If foreground objects are an important part of the image, be sure to let the lab know so they don't print the sky too dark. Otherwise, the foreground may be nearly indistinguishable from the sky.

Some images were just not meant to be. A bright Moon at the top, mercury vapor lighting at the bottom, and a rude aircraft in the middle conspired against Orion. Note the washed-out red in Betelgeuse and the Orion Nebula. Lens: 50mm. Exposure: 15 seconds at f/2. Film: Kodak Provia 100F.

Scanners and digital processing are a good option for processing images since they allow the photographer to retain control over the print. Many people prefer this approach because it allows them to make adjustments according to their tastes. If you do not have a scanner, it is possible to have images commercially scanned and stored on a compact disc or other computer media. Then you can modify these files on your computer.

The conventional but informal standard is that the background for most images of stars, planets, and deep-sky objects should be black or very dark gray. While there is nothing wrong with these backgrounds, you don't have to let tradition limit your color choices. In reality, even dark skies have a bluish cast and the sky becomes more blue when illuminated by the Moon. On the other hand, if you are having prints made and want a neutral dark gray or black sky, you should tell the lab to adjust the color balance to produce such a background.

Case Study: Why Photographers Should Advocate for Dark Skies

The control of light pollution does not mandate unreasonable measures.

Light pollution affects a much larger population than astronomers and astrophotographers. It affects everyone who can appreciate the beauty of the environment. Unfortunately, light pollution has become so pervasive in the United States that most people can no longer identify the Milky Way or find the Little Dipper. Furthermore, even people who do not care about the night sky must still pay the taxes and other costs associated with directing billions of dollars worth of energy each year toward the sky. Imagine a situation where museums and art galleries were required to shield their works behind a thin layer of gauze so visitors would not be able to appreciate their detail and full glory. Further imagine that citizens were required to pay taxes to install and maintain the gauze whether or not they appreciated art.

Safety and health are other reasons to be concerned about light pollution. Glare generated by unshielded or improperly directed outdoor lighting diminishes the ability to see and can adversely affect the safety of drivers and pedestrians. Research has indicated that too much light at night has the potential to adversely affect health by disrupting natural hormone production. In some cases, lighting is believed to contribute to crime. For example, several school districts found that loitering and vandalism decreased after they turned off exterior lights.

Furthermore, the control of light pollution does not mandate unreasonable measures. Where illumination is needed to improve safety, lighting can still be shielded and appropriately sized for the task. The vast majority of the light that causes light pollution serves no beneficial purpose. By controlling light pollution, society can save money and energy resources. Several organizations, such as the International Dark Sky Association (www.darksky.org), provide educational information to citizens and municipal governments about how they can protect the night sky and reduce costs.

4. Shooting the Moon and Sun

The Moon and the Sun are the most prominent celestial objects and are similarly sized at about 0.5 degrees in angular diameter when viewed from Earth. Otherwise, they are very different physically and photographically. The Moon is a rocky satellite orbiting Earth and is illuminated by the Sun. It offers excellent photographic opportunities because it varies in shape, intensity, and location throughout the month and year. It also has visible surface detail that enhances its appeal as a photographic subject. The Sun, of course, is the closest star to Earth and emits its own light. It is also the brightest star visible from Earth at magnitude -26. The Sun can be an interesting object to photograph, although one must consider its extreme brightness with regard to photographic and safety considerations.

The Moon

The Moon actually has two types of orbit around Earth depending on the point of reference. It moves around the celestial sphere once every 27.3 days as referenced from Earth. This is called a sidereal month. However, the Moon takes 29.5 days to return to the same point on the celestial sphere as viewed from the Sun, because Earth is moving around the Sun. This is called a synodic month and correlates to the lunar phases observed from Earth. The Moon rotates around its axis every 27.3 days since the Moon and Earth are tidally coupled. The coupling of the periods for orbit and rotation means that the Moon keeps substantially the same face turned toward Earth.

Phases of the Moon. The phases depend on the angle of the Moon relative to Earth and the Sun (no, they are not caused by Earth's shadow on the Moon). The lunar cycle begins when the Moon is located between Earth and the Sun. This phase is called the New Moon. Since the New Moon is generally aligned with the Sun, it rises at about the same time as sunrise and sets at

The Moon is a rocky satellite orbiting Earth and is illuminated by the Sun.

about the same time as sunset. The unlit side of the Moon faces Earth, which makes it invisible in the glow of the Sun. As the Moon proceeds between the New Moon and the First-Quarter Moon, it is called a Waxing Crescent Moon. In the northern hemisphere, the Waxing Moon is shaped like a "D." The portion of the Moon directly illuminated by the Sun appears as a bright crescent. The remainder of the Moon is dimly illuminated by light reflecting from Earth. This is known as earthshine.

The first quarter occurs when the Moon has completed one-quarter of the lunar cycle. During this phase, the Moon is 90 degrees away from the Sun, so only half of the Moon's face appears lit from Earth. The First-Quarter Moon rises at noon and sets at midnight. Between the First-Quarter and the Full Moon, the phase is called Waxing Gibbous Moon and it progressively increases in brightness.

The Full Moon occurs halfway through the lunar cycle when the Moon is 180 degrees from the Sun and completely front-lit. Because the open structure of the lunar soil makes it highly reflective when opposite the Sun, the Moon's brightness between the quarters increases significantly. The Full Moon rises at sunset and sets at sunrise.

The Moon is a rocky satellite that orbits Earth and is illuminated by the Sun.

Once past full, the Moon wanes to its last quarter. This phase occurs about a week after the Full Moon. The Last Quarter Moon rises at midnight and sets at noon. While waning, the Moon is shaped like a "C." The Waning Moon has gibbous and crescent phases in the same manner as the Waxing Moon.

The brightness of the illuminated portion of the Moon varies with its phase. The gibbous phases are about half as bright as the Full Moon, the Quarter Moons are about one-fourth as bright, and Crescent Moons are about one-eighth as bright. Although the phases are not caused by Earth's

Left—A good time to photograph the Moon is shortly after sunset about two days after the New Moon. Note how the Waxing Moon is shaped like a "D." Lens: 80–200mm. Exposure: ⅛ second at f/8. Film: Fuji Velvia.
***Below**—The Moon at first quarter. Lens: 180mm + 1.4x teleconverter. Exposure: ¹/₂₅₀ second at f/8. Film: Fuji Velvia.*

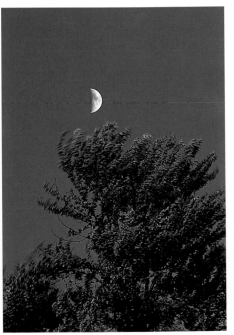

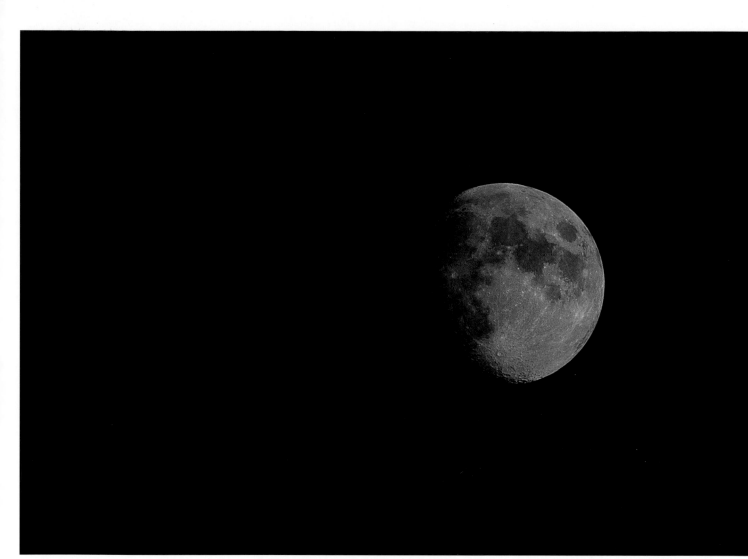

Waxing Gibbous Moon. 200mm f/5 Newtonian reflector telescope. Exposure: 1/350 second at f/5. Film: Fuji Provia 100F.

shadow, Earth sometimes casts its shadow on the Moon, which results in a lunar eclipse. When this happens, the Moon turns a red-orange color and its brightness diminishes considerably.

Exposure Guidelines. Determining exposure parameters for the Moon is not too difficult. If you are making an image during the day that includes the Moon, any exposure that is appropriate for the sky should work well. At twilight and night, the considerations become a little more involved.

Since the Moon has a gray sunlit surface, a good starting point for exposure is the "Sunny 16" guideline. This guideline, which is used to estimate terrestrial exposures in bright sunlight, applies equally well to the Full Moon. To estimate an exposure for the Full Moon, set the shutter speed at the reciprocal of the ISO speed of the film. This means that a good starting exposure for a Full Moon with an ISO 100 film would be about 1/90 second at f/16. If the lens were opened up from f/16 to f/11, the shutter speed would again be twice as fast (i.e., 1/180 second). These exposures should ensure that the surface detail of the Moon will be retained in the image.

The exposure needs to be increased at phases less than the Full Moon. An easy way to remember how much to adjust is to increase the exposure by one stop for each reduction in partial phase. In other words, the exposure should

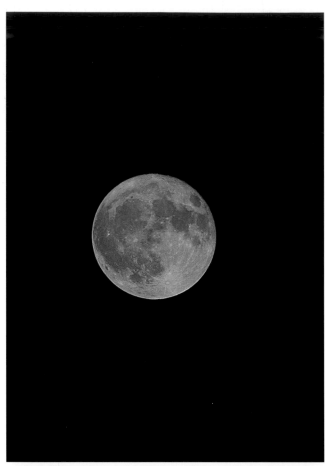

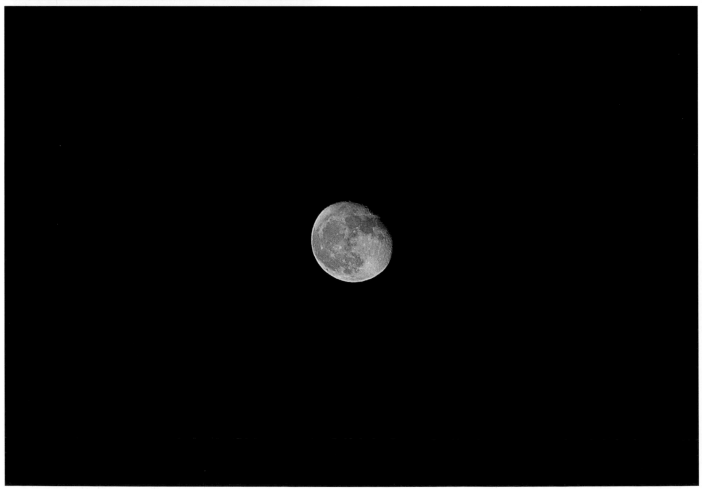

Left—Full Moon. Lens: 200mm f/5 Newtonian reflector telescope. Exposure: ¹⁄₇₅₀ second at f/5. Film: Fuji Provia 100F. **Below**—Waning Gibbous Moon. Lens: 180mm with 1.4x teleconverter. Exposure: ¹⁄₁₂₅ second at f/8. Film: Kodak E100SW.

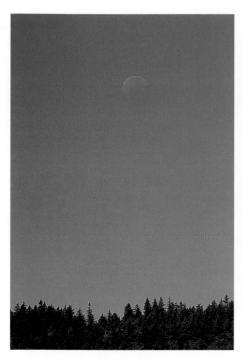

Top Left—*The Waning Moon at last or third quarter. Lens: 200mm. Exposure: ¹/₁₂₅ at f/11. Film: Fuji Velvia.* **Top Right**—*The basic rule for daytime exposures of the Moon is to expose for the sky. Lens: 80–200mm. Exposure: ¹/₁₂₅ at f/8. Film: Fuji Velvia.* **Right**—*Another good time to photograph the Moon is shortly before sunrise about two days before the New Moon. Note how the Waning Moon is shaped like a "C." Lens: 24mm. Exposure: ½ second at f/8. Film: Fuji Velvia.*

be increased one f-stop for a Gibbous Moon, two f-stops for a Quarter Moon, three f-stops for a thick crescent, and four f-stops for a thin crescent. Judging exposure during a lunar eclipse is difficult because the brightness varies as the eclipse proceeds and eclipses have different brightness. Depending on the eclipse, exposure times using ISO 100 film at f/4 can range from 1/125 second to four minutes. Bracketing of exposures is recommended.

The brightness of the Moon makes it difficult to photograph with landscape elements at night. As the sky darkens, the film's exposure latitude will no longer be able to properly expose the Moon with the other elements in the photograph. When this happens, exposing an image properly for the foreground will result in the Moon being overexposed. Conversely, selecting the proper exposure for the Moon will underexpose the foreground. Overexposing

Determining the proper exposure for a lunar eclipse is difficult because they differ in brightness. This image of the Painted Hills in Oregon was selected from several bracketed exposures ranging from two to fifteen seconds. Lens: 50mm. Exposure: 8 seconds at f/2. Film: Konica Centuria 800.

Diameter of the Moon on Image	
Focal Length	Image Diameter
25mm	0.22mm
35mm	0.32mm
50mm	0.46mm
105mm	0.96mm
135mm	1.24mm
200mm	1.83mm
300mm	2.75mm
500mm	4.59mm

Earthshine Exposure Times (seconds)							
	Focal Ratio						
Film Speed	f/2	f/2.8	f/4	f/5.6	f/8	f/11	f/16
100	2	4	8	15	30	—	—
200	1	2	4	8	16	30	—
400	½	1	2	4	8	16	—
800	¼	½	1	2	4	8	16

the Moon when between the full and quarter phases usually results in the "hole punch" effect in which the complete loss of detail in the Moon creates the impression that someone has cut a circle out of the image.

There are more options for exposing the crescent phases of the Moon. Since the Moon at this phase shows little surface detail, it is possible to over-expose and still obtain an acceptable image. Should a Crescent Moon be exposed over a period of several seconds, the image will begin to show detail in the earthshine part of the Moon. Initially, the earthshine will appear as a grayish moon with a very bright crescent. This approach can work well for exposures up to about thirty seconds if wide-angle lenses are used. If the exposure time is increased even more, the earthshine becomes grossly over-exposed and will lose detail. However, it will often retain a yellowish shade that is not as displeasing as the hole punch effect associated with the fuller phases. The ability to retain some of the color of the Moon can be used to artistic advantage when making night images containing the Crescent Moon. To expose for earthshine, try using the film speeds and focal ratios described above.

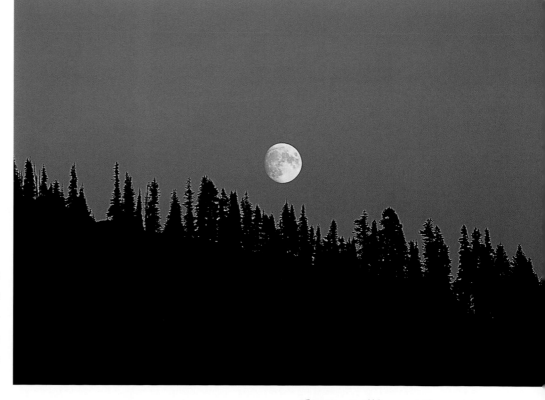

A Gibbous Moon needs less exposure than a Full Moon but generally can be exposed at the same exposure for the sky as twilight approaches. Lens: 180mm + 1.4x teleconverter. Exposure: ¹⁄₉₀ second at f/8. Film: Fuji Provia 100F.

Facing Page—The dreaded hole punch effect occurs when the Moon is grossly overexposed. This most commonly occurs when the exposure is determined for the overall image and the brightness of the Moon exceeds the film's exposure latitude. Lens: 180mm + 1.4 teleconverter. Exposure: 6 seconds at f/8. Film: Fuji Velvia.

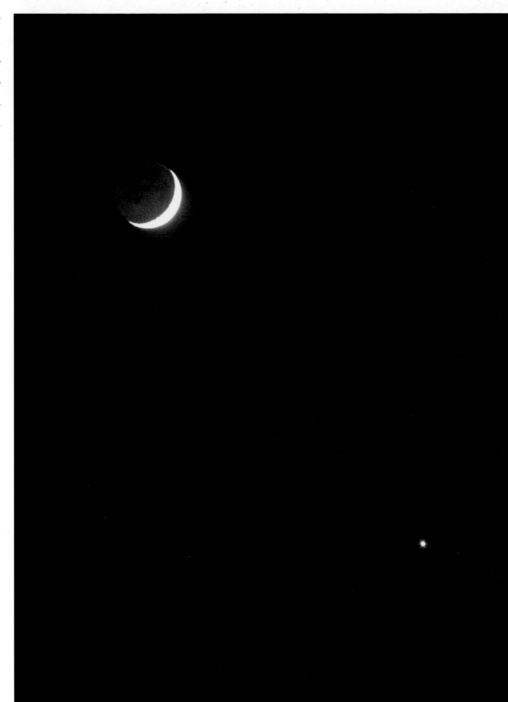

In this case, the Moon was exposed for earthshine to enable Venus to record on the image. The part illuminated by the Sun is burned out, but the overall effect is pleasant since the earthshine portion of the Moon shows detail. Lens: 385mm. Exposure: 1.5 seconds at f/4.5. Film: Konica Centuria 800.

Focal Length and Composition. Focal length is an important consideration when photographing the Moon because it will determine the size of the Moon on the image. Since the Moon is only 0.5 degrees in diameter, it will appear quite small when photographed with normal and wide-angle lenses. When photographed with long telephoto lenses, the Moon will appear significantly larger. Depending on compositional choices, successful images of the Moon can be made with all focal lengths.

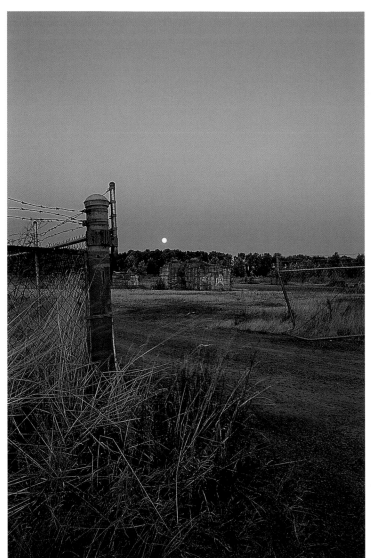
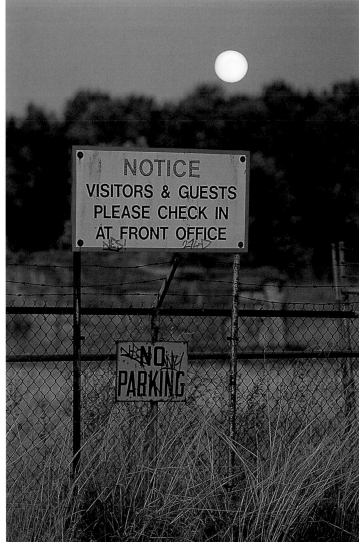

*Left—Short focal length lenses tend to be overlooked as tools for photographing the Moon, but the smaller image can augment a sense of spaciousness. Lens: 24mm. Exposure: ¹/₁₅ second at f/22. Film: Kodak E100SW. **Right**—The Moon can be used in telephoto images to create a sense of compression. Lens: 180mm + 1.4x teleconverter. Exposure: ⅛ second at f/22. Film: Kodak E100SW.*

To determine what the diameter of the Moon will be on an image, divide the focal length by 109. For example, the diameter of the Moon in an image made with a 50mm lens will be 0.46mm (50mm ÷ 109). A table of the image size associated with common focal lengths is shown to the right.

Diameter of the Moon on Image	
Focal Length	Image Diameter
25mm	0.22mm
35mm	0.32mm
50mm	0.46mm
105mm	0.96mm
135mm	1.24mm
200mm	1.83mm
300mm	2.75mm
500mm	4.59mm

There are some advantages to using lenses with short focal lengths to photograph the Moon. The wide angles of view encompass a lot of sky, which gives you more leeway regarding the altitude of the Moon off the horizon. In addition, the smaller image size of the Moon is more tolerant of overexposure. On the other hand, long lenses can produce images where the Moon is of dramatic size. The ability of long lenses to show detail in the Moon can augment the impression made by an image.

Balancing the Exposure of the Moon with Other Elements. A difficult aspect of making images containing the Moon is ensuring that its exposure

Top—Waiting for cloud cover to shroud the Moon can help avoid the hole punch effect. Lens: 80–200mm. Exposures: 6 seconds at f8. Film: Fuji Velvia. **Bottom**—The Moon is used to accent the sculpture Fortuna by Simon Toparovsky. The "hole punch" effect caused by gross overexposure of the Moon was softened by leaving it out of focus. There was also a slight atmospheric haze present. Lens: 50mm. Exposure: 1 second at f/4. Film: Fuji Superia 400.

does not clash with the exposure of the other elements. Since the Moon becomes much brighter than most terrestrial objects after the Sun sets, an important part of determining the composition is managing the exposure to retain a pleasing appearance. Depending on the phase, there is a short period near sunrise or sunset when the base exposure for the other elements in the image coincides with the correct exposure of the Moon. However, the more common situation is that exposing the other elements correctly will result in overexposing the Moon.

While overexposing the Moon is a significant problem in images featuring mixed elements, it is sometimes possible to reduce the effect of overexposure. One way is to use a graduated neutral density filter to hold back the exposure in the sky. These filters, which are darker on the upper half, reduce the light in the upper part of the image from one to three stops. However, since the difference in exposure for the Moon and terrestrial elements in a night photograph can be twenty stops or more, graduated neutral density filters offer a limited solution.

Another way to lessen the effect of overexposure in landscapes and other photographs with terrestrial elements is to place the Moon out of focus. Although the Moon will lose detail, the softened borders and tendency to retain some color reduces the severity of the hole punch effect. This technique works particularly well when the Moon is near the horizon where it tends to show more color due to increased atmospheric scattering. Another related technique is to wait until the Moon is behind cloud cover or haze. Overexposure in such cases tends to create a corona effect that is usually preferable to the hole punch effect.

As discussed above, images containing the Crescent Moon do not really need detail in the Moon to appear realistic. The increased tolerance of overexposure allows for considerably more latitude with regard to selecting a working exposure.

Left—Using a wide-angle lens in flash exposures allows you to take advantage of the greater depth of field. Lens: 50mm. Exposure: 1/125 second at f/16. Film: Fuji Provia 100F. **Right**—*The brightness of the Moon enables you to balance its exposure with the flash exposure of nearby subjects. Lens: 105mm. Exposure: 1/125 second at f/32. Film: Konica Centuria 800.* **Facing Page**—*The Full Moon makes a reasonably bright illumination source when fast film and lenses are used. Lens: 50mm. Exposure: 20 seconds at f/2. Film: Fuji Superia 400.*

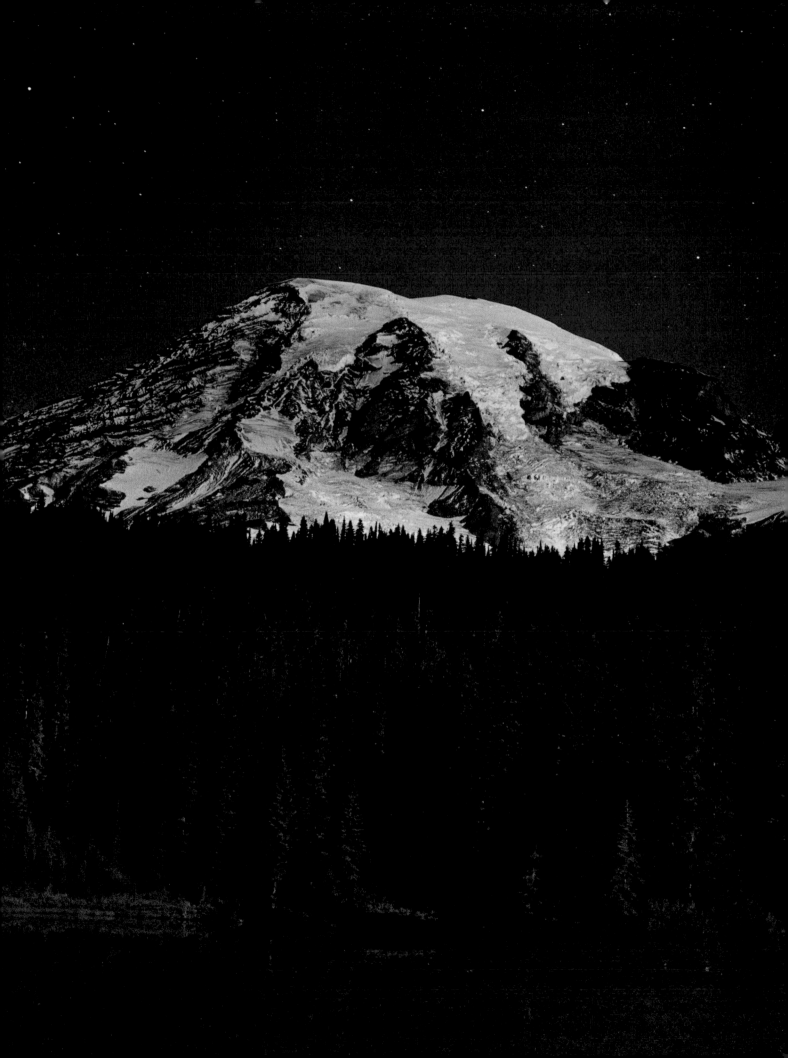

Another approach to balancing exposures is to use flash to illuminate the foreground elements. When using flash, set the shutter speed and focal ratio to expose the Moon and set the flash to expose the foreground. Since the Moon is a bright object, it is usually feasible to use a reasonably fast shutter speed and a focal ratio that provides for a good depth of field.

Moonlight Photography. One of the easiest ways to deal with the high brightness of the Moon is to leave it out of the photograph altogether and use it as an illumination source. Selecting an exposure for a moonlit photograph is very subjective. It is possible to expose a moonlit photograph enough that it almost resembles one taken by daylight. If your goal is to make the image look as if it were taken at night, exposures can be fairly short if fast films and fast lenses are used. While you can use medium speed films at medium focal ratios, make sure that the film you use has good reciprocity characteristics. You will need to experiment to determine what exposures you prefer.

Due the structure of lunar soil, it is remarkably reflective when opposite the Sun. This means that the Full Moon reflects much more light onto Earth than a Gibbous or Quarter Moon. A good starting point when the Moon is within three days of being full is to use an ISO 400 film exposed from fifteen to sixty seconds at f/2.8. When the Moon is four to five days from full, the exposure should be increased by one stop; and when six to seven days from full, the exposure should be increased by two stops. For a Crescent Moon, increase the exposure by at least three stops or estimate the exposure based on twilight conditions.

As the closest star to Earth, the Sun is a very impressive object.

The Sun

As the closest star to Earth, the Sun is a very impressive object. Whereas the light from other bright stars takes anywhere from four to 1,500 years to reach Earth, the Sun's light takes only eight minutes. As a magnitude -26 star, it is impossible to incorporate the Sun into images of terrestrial subjects without overexposing it. Because the Sun is a white star, the lack of detail when it is overexposed does detract from images as is the case when the Moon is overexposed.

Protecting the eyes is very important when making images of the Sun. The light from the Sun is very high in ultraviolet wavelengths, which can cause photochemical damage to the retina. Infrared and other spectra emitted by the Sun can burn the retina when concentrated by binoculars or a telescope. Under conditions of unaided viewing, the eye protects itself by constricting the pupils and blinking when stimulated by the intense light. When the Sun is more than a few degrees off the horizon, viewing becomes very uncomfortable and usually results in squinting and tearing. However, unless the Sun is intensified by optics such as telescopes, binoculars, or telephoto lenses, short glances usually do not cause eye injury. Viewing becomes safe when the Sun approaches the horizon because it passes through more atmosphere, which

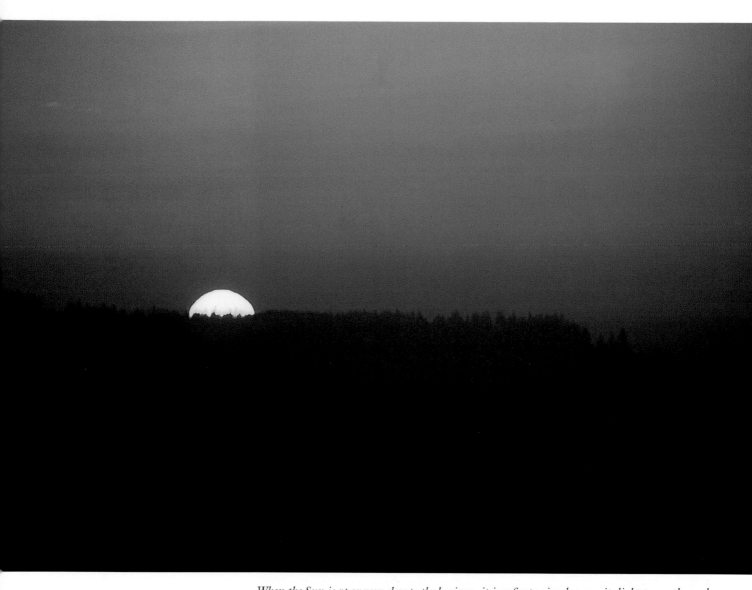

When the Sun is at or very close to the horizon, it is safer to view because its light passes through a thicker layer of atmosphere. Lens: 180mm lens with 1.4x teleconverter. Exposure: 1/250 second at f8. Film: Fujichrome Velvia.

The eyes are most vulnerable to injury when the Sun is partially obscured. . . .

decreases its brightness and scatters the ultraviolet fractions. The region for safe viewing is about 2 degrees and less above the ocean horizon, which corresponds to the period starting about eight to ten minutes before sunset.

Ironically, the eyes are most vulnerable to injury when the Sun is partially obscured such as during a partial phase of a solar eclipse or when using inappropriate eye protection such as sunglasses or a strip of exposed film. In these cases, viewing does not exceed the discomfort level and the partially dilated pupils can allow harmful amounts of ultraviolet light to reach the retina. This explains why cases of eye damage (solar retinopathy) tend to increase significantly after solar eclipses. In most cases, victims of solar retinopathy regain their full vision within a few weeks although some suffer long-term visual impairment. However, the anatomic damage to the retina is permanent. The Sun may not be as notorious a cause of injury as some make it out to be, but attention to safety is definitely warranted.

The Sun can be safely viewed and photographed through a telephoto lens or telescope if a solar filter is placed over the front opening. It is important to use filters made for solar viewing that adequately attenuate all the wavelengths that can damage the eye. Some materials, such as exposed film and neutral density filters, are dangerous since they pass harmful wavelengths but block the ones that trigger the eye's protective mechanisms. Use only quality filters made specifically for solar viewing. Never use a filter that attaches to a telescope eyepiece. These filters are likely to crack and shatter because they absorb intense heat that has been concentrated by the optics. If you ever run across one of these filters (they are sometimes found in cheap telescope kits), throw them away.

You should also take reasonable care to protect your equipment. Stories abound about photographers with Leicas who burned holes in the shutter by pointing them at the Sun. Sun damaged equipment does not appear to be a big issue, but it is always a good idea to place a cap on your lens when you are not using it.

Above—The Sun may be safely viewed through a telephoto lens if you place a filter made for solar viewing in front of the lens. Below—With a solar filter and telephoto lens, imaging sunspots is easy and safe.

Due to the extreme brightness of the Sun, it is impossible to properly expose it and any other elements in the same image. In fact, the Sun is so bright that it is very difficult to properly expose it at all without special filtration. On the other hand, there are few occasions when overexposure is a

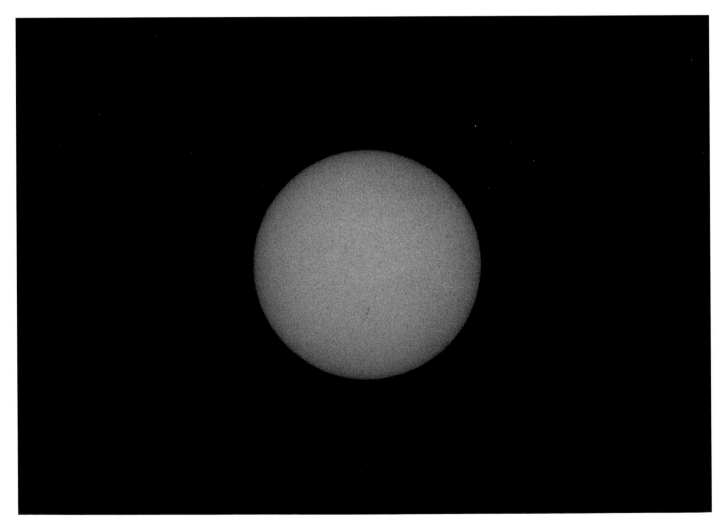

One way to incorporate the Sun into an image without flare is to photograph on a day when thin intermittent cloud cover acts as a screen. Lens: 24mm. Exposure: ¼ second at f/8. Film: Fuji Velvia.

problem. The significant problem with placing the Sun in images is lens flare. Flare is caused by internal reflections within the lens and typically shows up in an image as a series of hexagons. Modern multicoated optics can reduce flare but cannot eliminate it when shooting into a bright light such as the Sun. Although the traditional means of controlling flare, the lens hood, does not work when the Sun is in the image, there are measures you can take to minimize the effect of flare in an image. Prime lenses are better for making images that contain the Sun since they usually have fewer elements than zoom lenses and therefore fewer sources of internal reflections. Removing filters can also reduce flare. If flare cannot be avoided, the effects on the image can be minimized. When composing the image, check for the location of the flare and arrange the image to minimize disruptive effects. Stopping the lens down to a smaller aperture will also minimize flare. On days with thin cloud layers, it is sometimes possible to photograph the Sun without flare appear-

ing in the image. Getting a good picture often requires considerable patience in waiting for cloud cover that is sufficient to attenuate glare but thin enough to let the Sun through.

One occasion in which you will probably want the Sun to be reasonably exposed is during a solar eclipse. An eclipse is caused by the Moon shadowing the Sun's light as viewed from Earth. When the Moon completely shadows the Sun a total eclipse occurs, and the Sun is completely blacked out except for its gaseous corona. When the Moon is on the far side of its orbit

Facing Page—By using black & white negative film, printing on low contrast paper, and judicious burning, you can squeeze out enough latitude to print the basic elements. Lens: 50mm. Exposure: $\frac{1}{1000}$ second at f/16. Film: Fuji Acros.

Incorporating a partial solar eclipse into an image is very difficult because the Sun is so much brighter than anything else in the scene. Slide films do not have enough latitude to record the eclipsed portion. Lens: 50mm. Exposure: $\frac{1}{1000}$ second at f/16. Film: Fuji Provia 100F.

its angular diameter is slightly smaller than the Sun's, and an annular eclipse occurs in which a small ring of the Sun remains visible. Partial eclipses occur when part of the Moon shadows part of the Sun. To avoid eye damage, do not use a telephoto lens or telescope to photograph an annular or partial solar eclipse without a proper solar filter. Normal and wide-angle lenses can be used to photograph eclipses without filters provided that you rigorously minimize the amount of time you look through the viewfinder. This can be facilitated by using a tripod and prefocusing at infinity. You will need to bracket your exposures as much as possible. Print films are recommended because they have more exposure latitude than slide films.

Partial eclipses occur when part of the Moon shadows part of the Sun.

Flare from the Sun is caused by a combination of internal reflections in the glass of the lens and diffraction through the aperture. Internal reflections can be avoided by making images with a pinhole, although this increases the diffraction. The diffraction spikes made by a pinhole tend to be more diffuse than those made by lenses. Image made on Agfa APX 100 film, 6x6cm, 0.35 pinhole, focal length 87mm, f/250.

5. The Night Sky with Camera and Tripod

A camera mounted on a tripod has much greater capabilities for astrophotography than many photographers assume. For example, images intended to show constellations as they appear to the human eye require exposures of a few seconds, which is well within the capability of a camera on a tripod. For applications that incorporate astrophotography into conventional genres such as landscape photography, a camera and tripod setup is much more suitable than any of the techniques that track the movement of the sky.

Camera and tripod techniques can be classified into star trail and fixed-point categories. Star trail astrophotography uses long exposure times to record the semicircular movement of the stars around the celestial pole. In fixed-point astrophotography, the exposure times are limited to reduce the trailing of stars to unnoticeable levels. Both methods use the same equipment and involve many of the same considerations. They differ significantly, however, with respect to how exposures and compositions are determined.

Celestial objects move across the sky much faster than many people assume. . . .

Basic Techniques

Preparation will make any astrophotography session more efficient. Simple things such as loading the camera with film and setting the shutter speed and f-stop before a session can save a lot of time since these tasks are more difficult in the dark. It is also helpful to have selected a location prior to traveling to the site. Celestial objects move across the sky much faster than many people assume, and good opportunities can be missed if you spend too much time scouting and setting up.

Setting up a camera in the dark can be a trying matter if you have not done it before. It is a good idea to practice operating the controls on your camera and setting up a tripod with your eyes closed. Once a routine is established, operating a camera in the dark (even with mittens) becomes second nature.

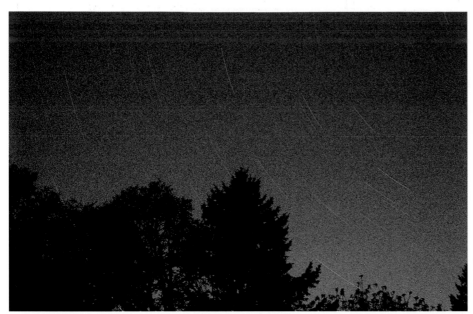

Left—Aircraft show up on images as a series of points made by blinking navigation lights. Most astrophotographers are familiar with them. Lens: 50mm. Exposure: 45 minutes at f/8. Film: Kodak Ektachrome P1600. **Below**—Satellites leave their mark on images in the form of thin lines. Lens: 50mm. Exposure: 15 seconds at f/2. Film: Konica Centuria 800.

Passing lights are not always disasters. A vehicle came down the street during this exposure and inadvertently illuminated the "No Dumping" sign in front of the Big Dipper. Lens: 24mm. Exposure: 20 seconds at f/4. Film: Kodak E100SW.

Selecting Locations. While location is a primary consideration for most photography, selecting a good vantage point can be even more critical for astrophotography. The major concerns with respect to astrophotography are long exposures and extraneous light sources. Wind and traffic vibrations are another consideration. Candidate locations can be scouted during the day or even by looking through your prior images. Once a promising spot is found, you can use star mapping software to determine which objects will be in the frame of view at any given time.

When evaluating a site for extraneous light, you want to ensure that the camera will be protected from glare and that artificial lighting will not degrade your view of the sky or cause an unwanted color cast to foreground elements. Some sources, such as street lights, are obvious. Other sources, such as a neighbor turning on a porch light or passing pedestrians shining flashlights on your gear are more subtle but nonetheless need to be taken into account. Distant lights will appear more significant in images than they were when observed at the site. Transient lights can be an insidious problem since they sometimes are impossible to detect while the image is being made. For example, aircraft lights that are too far away to be discerned visually are sometimes recorded by films that are more sensitive than the human eye. Satellites also have a knack for sneaking into images. The best way to avoid aircraft lights is to photograph subjects that lie outside of flight paths or work when air traffic is minimal.

Candidate locations can be scouted during the day. . . .

Focusing. Focusing is a major challenge in astrophotography since dim point-sized subjects are difficult to see in viewfinders. Using lenses that focus at infinity at their focusing stops simplifies the focusing process since all the photographer has to do is turn the focusing ring all the way to the focusing stop. However, some lenses are designed to focus past infinity to allow for compensation for temperature changes and other conditions. Furthermore,

some lenses that are designed to focus at infinity at the focusing stop will nonetheless focus best just short of the stop. In such cases, you need to be able to focus without relying on the focusing stop.

The most direct means of focusing at night is to use the viewfinder in much the same way that you focus during the day. Ground-glass viewfinder screens are the best for astrophotography because they show point images better than other kinds. Fresnel screen viewfinders reduce vignetting but preclude pinpoint images that make focusing easier. However, they can still be used to focus by moving the focusing ring back and forth until the "least bad" point of focus is found.

One approach to focusing, if you know that all your images will need to be focused at infinity, is to focus the lens during daytime and then secure the focusing ring with tape. This method works well provided enough tape is used to prevent accidental or inadvertent movement of the focusing ring. It is particularly helpful with wide-angle lenses, which are harder to focus accurately in the dark.

When determining focus at night, the key is to use all the perceivable information in the viewfinder to best advantage. Before attempting to focus, wait a few minutes to allow your eyes to acclimate to darkness. Once your eyes have adjusted, avoid looking at bright lights. Assuming that you are trying to focus at infinity, select an object at infinity that will be easy to focus on. The Moon is good when it is visible but planets and bright stars such as Vega or

Knowing where the Pleiades were located with respect to the bright planets Jupiter and Saturn facilitated this composition. Lens: 50mm. Exposure: 15 seconds at f/2. Film: Kodak E100SW.

Betelgeuse are usually adequate. Sometimes it is impossible to discern any celestial objects that are sufficiently bright for focusing. In such cases, bright lights in the distance can work well. When using fast, short–focal length lenses, one can sometimes use a flashlight to illuminate objects sufficiently far away to focus at infinity. This technique does not work well for long lenses, which reach infinity focusing at longer distances.

Magnifying the viewfinder screen can be a big help for cameras that accept such accessories. Most cameras that accept interchangeable viewfinders have a magnifying viewfinder as an option. In addition, many manufacturers offer magnifiers that attach to the eyepiece of the viewfinder. The accessories do not magnify as much as the interchangeable viewfinders nor do they allow full frame viewing, but some people find them helpful.

Another approach is to use a focusing tool such as a Ronchi screen. These screens are usually made of glass with precisely etched lines on one side. A good choice for astrophotography is a screen with 100 lines per inch. To construct a Ronchi screen focuser, you need to acquire a camera body with the same lens mount as the one you use for astrophotography. The camera does not need to be working, and bodies sold for parts or repair will usually suffice. Measure the distance from the other edges of the film rails and use a glass cutter to make the screen fit over the film rails. The screen can be secured using tape at the edges. To focus, place the camera body with the screen onto the lens mount. Move your eye very close to the screen, and you should see disks of light where stars are located. To complete the process, adjust the focus until the disks converge to points and then switch in a camera body with film.

Composition. As with focusing, bright viewfinders and magnification are useful aids for composing images. One of the difficulties common in astrophotography is that very little visual information can be seen in a viewfinder at night. When faced with these circumstances, you will probably need to compose the image by relying on the spatial relationship between the objects you can see in the viewfinder and those you cannot. One advantage to having a working knowledge of constellations is that you can use their relationships to bright stars to ascertain their location in the viewfinder. Another benefit to knowing how to find constellations is that they indicate the locations of deep-sky objects that can add interest to photographs. It is even possible to compose photographs that record objects too faint to be visible to the unaided eye by knowing where they exist relative to a particular constellation. This can be particularly useful when moonlight or light pollution reduces the visibility of celestial objects.

Star Trail Techniques

Star trails are among the easiest photographs to make since the equipment needs are minimal and the exposure considerations are fairly straightforward. They are also more amenable to artistic interpretation than other kinds of

Bright viewfinders and magnification are useful aids for composing images.

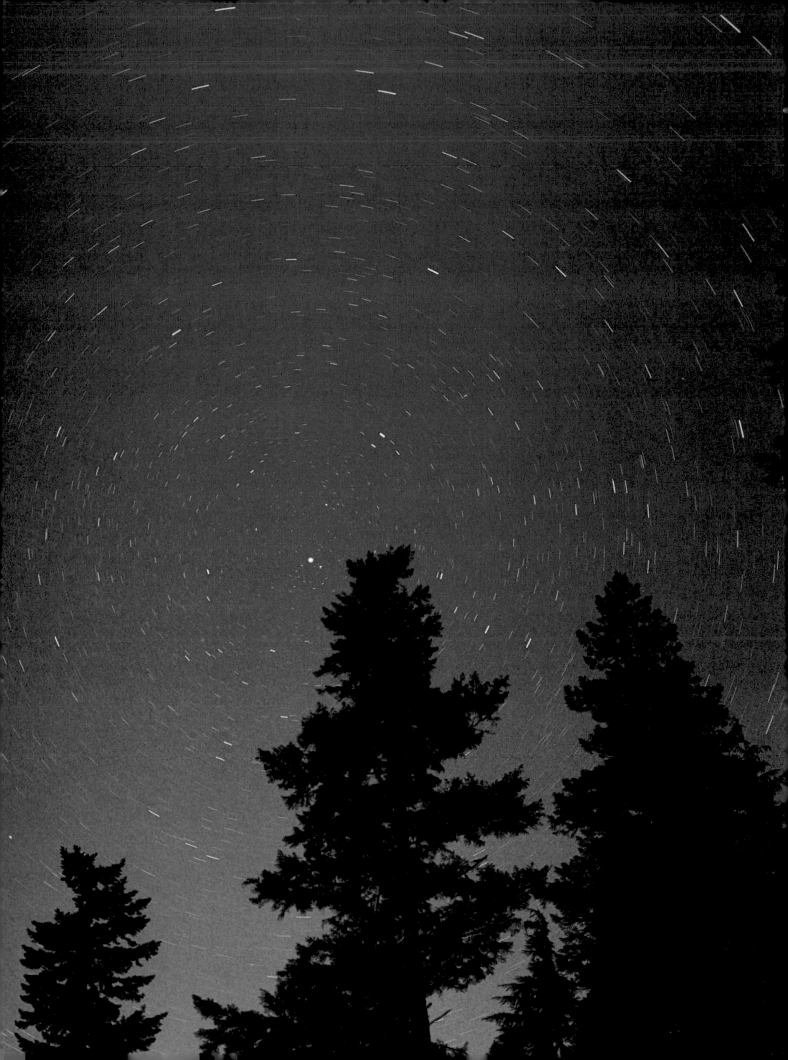

Facing Page—*Star trails provide interesting opportunities for expression. Polaris was aligned adjacent to the top of a Douglas fir and marks the center of rotation. Lens: 50mm. Exposure: About 5 minutes at f/2.8. Film: Konica Centuria 800.*

images in astrophotography. For example, star trails do not always have to be focused at infinity nor do they depend on specific celestial objects for their effect. Depending on technique, star trails can be long, short, dense, sparse, and exhibit different degrees of curvature. Star trail photographs are almost always more interesting if they include some terrestrial elements because of the additional visual interest and the associated artistic opportunities.

The number of trails that will appear in an image depends on several factors, including (1) the area of coverage of the lens, (2) the lens aperture, (3) the film speed, (4) the darkness of the sky, and (5) the part of the sky that is photographed. Star trails can be photographed under any night sky, but dark skies will result in richer densities with less sky fog. Wide-angle lenses cover a large area of sky, but the smaller physical apertures of these lenses cannot record as many dim stars as can lenses with larger apertures. Conversely, fast telephoto lenses have large physical apertures but cover a small area of sky. Although these lenses can pick up faint stars, images may look sparse due to the narrow field of view. Film speed and reciprocity characteristics will also affect how many trails are recorded. Films with good reciprocity characteristics often excel at recording the trails from dim stars, but are more susceptible to sky fog.

The main concern with exposure for star trail images is sky fogging, particularly with slide films. You can make star trails at exposures beyond the sky fog limit but will likely end up with a sky that has a noticeable color cast. So long as the cast is a pleasant color, this is not necessarily a bad thing. The best way to avoid problems with sky fog is to seek skies that are not affected by light pollution. Under such skies, exposure times lasting for several hours are quite feasible if the lens is stopped down somewhat. Under poor skies, stopping a lens down to f/5.6 or even f/8 will significantly delay the onset of sky fog but will also limit the number of stars recorded. If sky conditions are very good, stopping the lens down one or two stops from wide open can record more detail from the environment and reduce the effects of optical aberrations.

Two compositional considerations for composing star trail photographs are the length and width of the arcs that make up the trails. Since the sky rotates 15 degrees per hour, the rotation of Earth will produce star trails with an angular length of 0.25 degrees for each minute of exposure. For example, a ten-minute exposure will result in star trails of 2.5 degrees. Although the angular length in degrees depends solely on time, the resulting linear length on the image will also depend on how far the stars are from the celestial pole. Stars in constellations near the celestial poles, such as Ursa Minor, produce much shorter trails for a given exposure time than those near the celestial equator, such as Orion. Star trails close to the celestial pole will appear distinctly arced, and star trails close to the celestial equator will appear reasonably straight.

Since star trails form arcs with a radius centered approximately on Polaris, it is not difficult to predict the paths of stars trails in an image. This can be used to artistic advantage and allows you to incorporate the lines that will be made by trailing stars with other lines in the image. It is even possible to align the arcs formed with star trails with curved elements in the photograph using Polaris as the reference for the center point of the arcs.

The width of individual star trails is determined by the brightness of stars and should be taken into consideration when planning an image. By paying attention to bright stars, you can place them in a composition where their dominance will contribute to an image. Good groups of bright stars include the constellations Orion, Cassiopeia, and the Summer Triangle. It is usually a good idea to avoid placing bright stars or groups of stars in places where they draw the eye away from the primary subject. For example, placing Orion at the corner of an image will create very bright trails that can distract from the center of the image.

A final note about star trail photographs is that the lengthy exposures provide opportunities for additional photography but also increase the risk that extraneous elements may enter into photographs. Once the photograph has been set up and the shutter released, you are free to use another camera to make other kinds of images. Although star trails do not require intense concentration to photograph, they still require some monitoring to ensure that aircraft and satellites do not make their distinctive (and usually disruptive) tracks on an image and that passing vehicles and pedestrians don't shine lights onto your lens, which can cause flare.

Fixed-Point Techniques

Fast films with good reciprocity characteristics allow photographers to depict stars almost as pinpoint images. The key to the fixed-point image technique is to limit the exposure so that the trailing is too short to be objectionable. The extent of the trailing will be affected by three factors: the focal length of the lens, the declination of the objects photographed, and the exposure time. The point at which the trailing becomes objectionably noticeable is a subjective decision that only you can make. But most photographers rely on general guidelines for determining how long exposures should be for a given focal length. Furthermore, factoring in the declination of the objects being photographed allows for better control over the trailing effect.

Declination affects exposure time in two ways. The first is that the angular velocity of celestial objects increases the closer an object is to the celestial equator. For example, the apparent trailing of Polaris (Dec. = +89 degrees) near the north celestial pole is much less than the apparent trailing of Altair (Dec. = +8 degrees) near the celestial equator. This means that exposure times need to be shortened to reduce trailing as declinations approach the equator.

The second way declination affects exposure times is that since each focal length has a different angle of view, images will encompass different ranges of

Facing Page—It is easy to get discouraged about opportunities for astrophotography when it is cloudy, but star trail images can be made even under heavy clouds if there are intermittent breaks. Lens: 50mm. Exposure: About 5 minutes at f/2.8. Film: Konica Centuria 800.

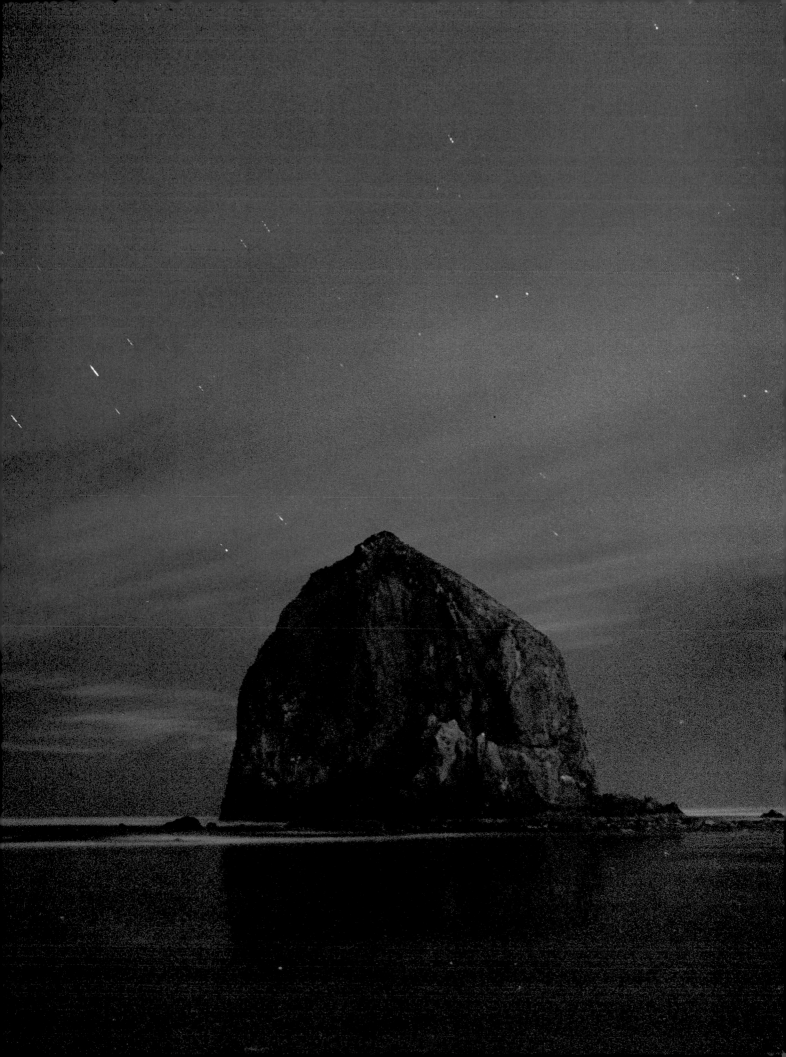

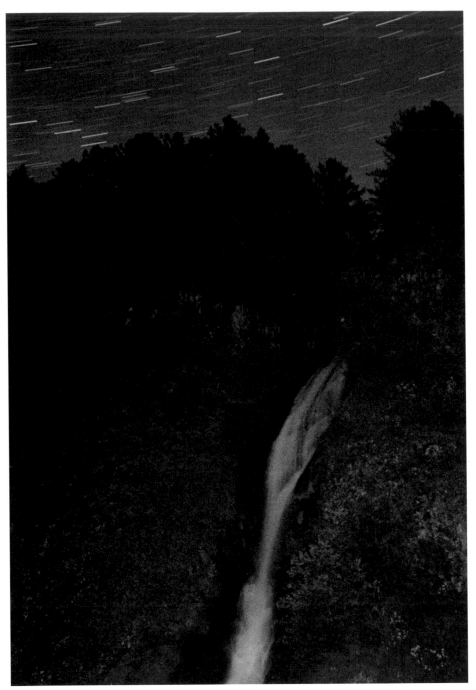

Stars tails will show less curvature the closer the stars are to the celestial equator. Flash was used to bring out some of the detail in the face of the mountain and the waterfall. Lens: 24mm. Exposure: 5 minutes at f/4. Film: Konica Centuria 800.

declinations depending on what focal length lens is used. For example, a 24mm lens will encompass about 42 degrees of declination on either side of the centerline, whereas a 135mm lens will encompass 9 degrees. Thus, the scene when pointing the camera at Polaris will encompass declinations ranging from +49 to +90 degrees with a 24mm lens and +81 to +90 degrees with a 135mm lens. If the camera is pointed at Altair, the declinations will range from -32 to +48 degrees for a 24mm lens and from -1 to +17 degrees with a 135mm lens. Knowing the relationship between exposure time and the onset of apparent trailing is particularly useful for telephoto lenses because the variation with declination is more extreme.

The best way to determine your personal tolerance to trailing is to experiment with exposure times. The following table provides conservative starting

points for general imaging of subjects at specific declinations. If you are unsure about the declination at the center of the image, following the general guideline will result in minimal trailing. It is usually possible to estimate declination by comparing the location of the scene to the locations of stars whose declinations you already know. Polaris, with a declination of +89, is very close to celestial pole where the declination is +90. Some prominent stars near the celestial equator are Mintaka (in Orion's belt) at 0 degrees, Altair at +8 degrees, Regulus at +11 degrees, and Spica at -11 degrees. Stars in the middle latitudes include Alkaid (at the end of the handle of the Big Dipper) at +49 degrees, Capella (in Auriga) at +46 degrees, and Deneb (in Cygnus) at +45 degrees. Alternately, you can carry a star map for a more precise reference.

As with any other kind of star photograph, the number of objects that are visible will depend on the part of the sky photographed, film speed, focal ratio, and aperture. The natural tendency of most astrophotographers is to get as many stars to appear in the image as possible. While there is nothing wrong with this approach, it is not a bad idea to consider whether you need all those stars. Some images look better with a sparse sky. Similarly, if you are trying to depict the sky as it appears visually, you usually need to cut back on

One compositional method with star trail photographs is to align the arcs with curved elements in the photograph. Since the arcs are centered around the celestial pole, their paths can be predicted by using Polaris as a reference point. Lens: 50mm Exposure: 45 minutes at f/2. Film: Kodak Ektachrome 100SW.

the exposure to avoid recording the visually imperceptible stars. This can be a real problem when photographing constellations since it is easy to lose the pattern made by the dominant stars in the clutter of minor stars when too many are recorded.

Special Subjects for Camera and Tripod

Planets. Five of the planets are bright enough to show up well in fixed-point photographs: Mercury, Venus, Mars, Jupiter, and Saturn. Venus is particularly suited to fixed-point astrophotography since its brightness and lack of sur-

Although most astrophotography images require stars to be sharply focused, deliberately focusing on terrestrial elements such as the leaves on these cottonwoods can provide a different kind of composition. Lens: 50mm. Exposure: 15 seconds at f/2. Film: Kodak E100SW.

Exposure Times (seconds)

Focal Length	General	Dec. = -30	Dec. = 0	Dec. = +30	Dec. = +60	Dec. = +90
24mm	20–25	20	20	20	22	31
35mm	14–20	14	14	14	18	28
50mm	10–15	10	10	10	13	25
85mm	6–8	6	6	6	8	23
105mm	5–7	5	5	5	7	23
135mm	4–5	4	4	4	6	23

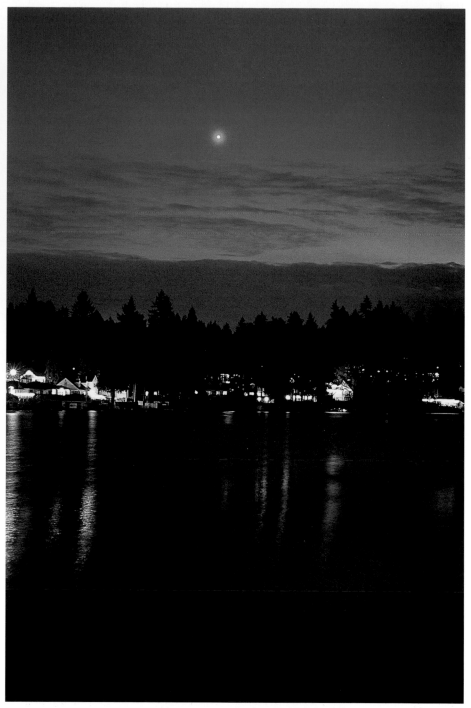

Above and Right—*Venus is the most prominent planet visually and stands out boldly in urban and natural settings. Lens: 50mm. Exposures: 10 seconds at f/2 and 6 seconds at f/2. Films: Fuji Superia 400 and Kodak E100SW.*

face detail give photographers a great deal of latitude regarding exposure. In addition, its reasonably large angular diameter makes it recognizable in images as Venus. Jupiter, Saturn, and Mars are not quite as bright as Venus and sometimes look like bright stars when they appear in images. Mercury is washed out by the Sun for most of the year but can sometimes be seen as a bright point in the upper twilight.

Meteors. Meteors, also known as shooting stars, are small pieces of matter that disintegrate as they pass through the atmosphere. Throughout most of the year, meteors occur intermittently in random parts of the sky and are difficult to capture in photographs. However, during meteor showers, they occur at a much higher frequency and originate from a point called a radiant.

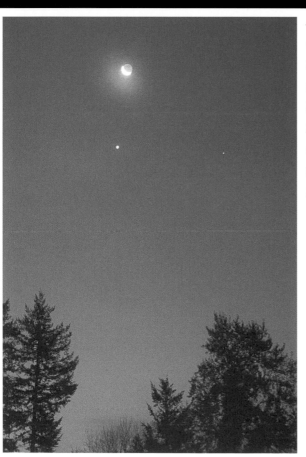

Above—The white featureless surface of Venus allows it to be photographed over a wide variety of lighting conditions. Lens: 50mm: Exposure: 10 seconds at f/2. Film: Provia 100F. *Left*—This conjunction features the Moon (3.5 days past last quarter), Venus (magnitude = -4.8), and the star Spica (magnitude = 1.0). Lens: 35–70mm. Exposure: 2 seconds at f/5.6. Film: Scotchchrome 640T. *Facing Page*—Mars, at the top of the trees at the right, varies greatly in brightness depending on its orbit relative to Earth. The planet was near its maximum brightness when this image was made. Lens: 50mm. Exposure: 20 seconds at f/2. Film: Fuji Superia 400.

Such events occur when Earth passes through a debris field such as those created by comets. Since Earth encounters these fields at one-year intervals as it orbits the Sun, meteor showers occur on predictable dates.

Meteor showers usually begin in earnest after midnight local time when the leading edge of the atmosphere rotates into the debris field and tend to peak between 2:00AM and 4:00AM. Since the times and locations of the radiant for a meteor shower are predictable, you should be able to plan ahead and select a good site from which to take photographs. Among the factors to consider are the suitability of the area where the photographs will be taken and the composition of the images. Dark skies are important since most meteors are faint and easily masked by light pollution. To the extent practical, one should try to avoid areas prone to dew or high wind. Since many of the meteors will travel toward or near the horizon, one may want to incorporate landscape elements into the photograph.

The easiest way to photograph meteors is to use a camera on a tripod with fast film. One way to do this is to use very long exposures. Since meteors are

Facing Page—(Top) The Moon, Jupiter, and Saturn lined up along the ecliptic. [Lens: 50mm. Exposure: 10 seconds at f/2. Film: Kodak E100SW. (Bottom) Four planets are visible along the ecliptic. Mercury is just above the clerestory of the condominium building; Venus is the bright object diagonally upward to the left, followed by Mars and Saturn. The bright orange star below Saturn and to the left of Mars is Aldebaran in the constellation Taurus. Lens: 24mm. Exposure: 10 seconds at f/4. Film: Konica Centuria 800.

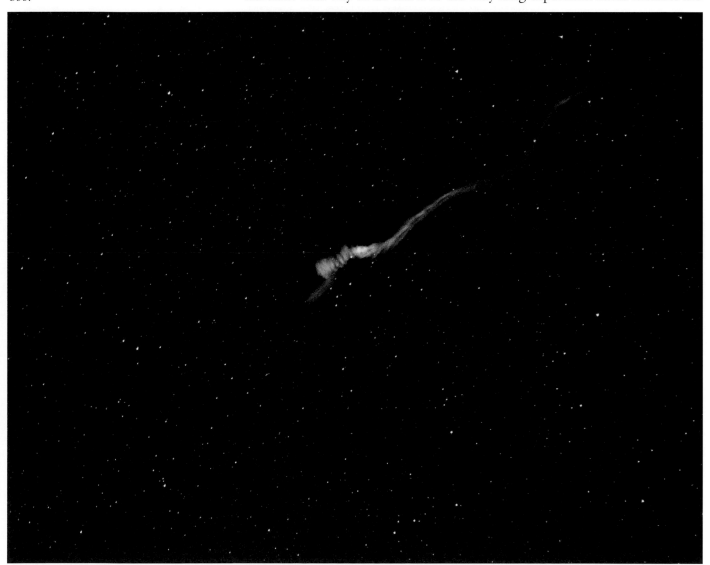

Large meteors called fireballs light up the sky and leave smoke trails in their wake. Lens: 50mm. Exposure: 10 seconds at f/2. Film: Fuji Superia 400.

recorded as short, straight lines, they are easy to distinguish from star trails. Another approach is to take sequential photographs using exposure times of about ten to twenty seconds. This approach minimizes star trailing but will usually result in missing meteors in most of the frames. However, it does increase the chances of capturing some very good images if the overall composition is good. Do not look through the viewfinder but instead look at the area where the camera is pointed. If you see a meteor pass through the area being photographed, stop the exposure and begin the next.

Although meteors originate from the direction of the radiant, it is usually best to aim the camera off to the side of the radiant since the trails made by the meteors will be longer. If possible, use several cameras aimed at different parts of the sky. It is also possible to experiment with combinations of cameras. A good combination is to use a camera with a wide-angle lens for long exposures while using another camera with a normal lens for shorter exposures. Telephoto lenses are generally not suited for meteor photography because of their narrow angle of view. However, they can produce nice images if you are lucky enough to capture one.

A 50mm lens is probably the best lens to use in terms of aperture and angle of view. Although wide-angle lenses cover a larger area of sky and thus increase the chance of incorporating meteors into their coverage, their lower effective apertures make them less effective at recording meteors. For example, the effective aperture of a 28mm lens stopped down to f/4 is only 7mm. In comparison, a 50mm lens stopped down to f/2 has an effective aperture of 25mm and thus collects much more light.

Facing Page—(Top) In terms of sheer efficiency, the physical aperture, and angle of view, the 50mm lens is the best overall choice for meteor photography. Lens: 50mm. Exposure: 20 seconds at f/2. Film: Kodak TMAX 3200. (Bottom) Fast telephoto lenses have large physical apertures and can be shot wide open with minimal aberrations, but their narrow angle of view greatly reduces the chance of capturing a meteor. On the other hand, it can be better to be lucky than good. Lens: 135mm. Exposure: 15 seconds at f/2.8. Film: Kodak TMAX 3200.

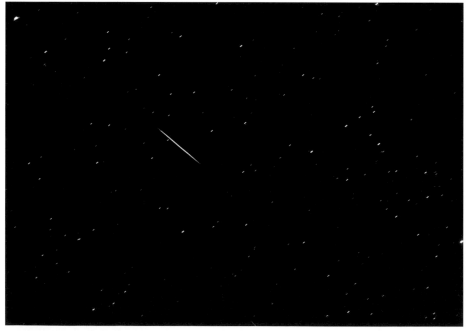

Modern color films easily record the vivd colors associated with meteors. Lens: 50mm. Exposure: 15 seconds at f/2. Film: Fuji Provia 100F.

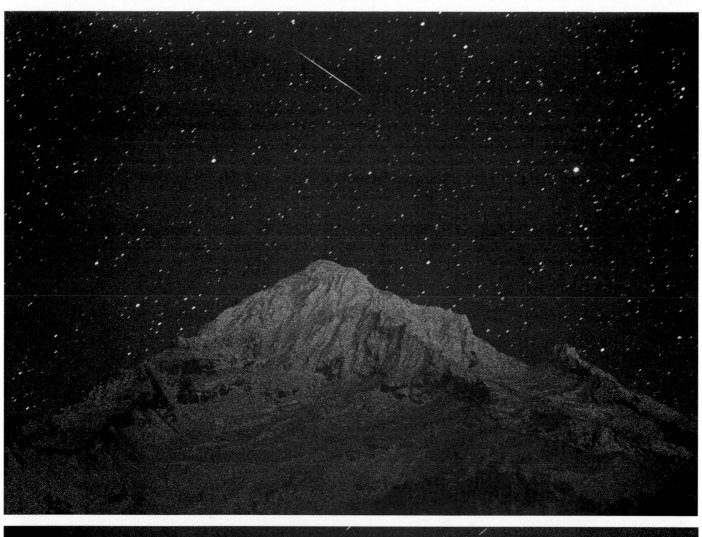

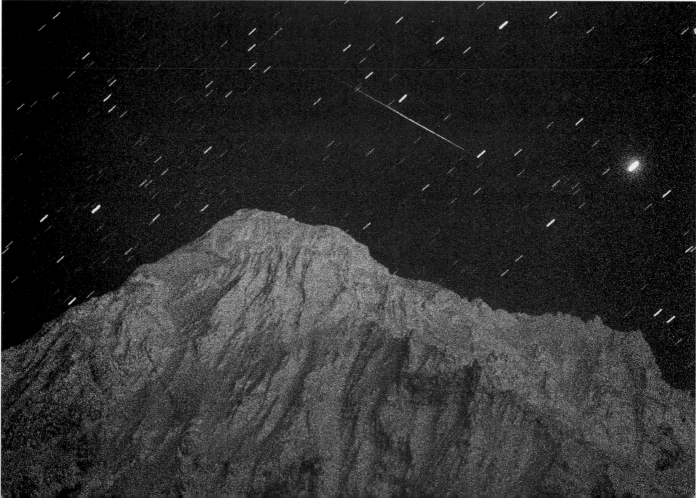

Facing Page—Comet Ikeya Zhang in 2002 was not the most impressive comet to orbit the Sun but was reasonably easy to image. Here it is located just east of the star β-Andromedae. The smudge at the edge of the photograph to the right of the comet is the Andromeda Galaxy. Lens: 50mm. Exposure: 15 seconds at f/2. Film: Fuji Superia 400.

Comets. One of the advantages to reading astronomy magazines or following astronomical highlights on the Internet is that you can get tuned in to the unexpected comets that show up every few months or so. Even though some of these comets approach or reach visual magnitude, they receive little attention from the popular media. However, they are easy to photograph if you know how to find them.

When looking for a dim comet, first obtain information about its location from astronomy magazines or similar resources. This information is usually given as ephemerides (table of astronomical coordinates by date) or by specifying the constellations where the comet will be located on specific dates. You will also need to go to an area with very good sky conditions. Using binoculars, scan the general area where the comet is located until you find it. To take the photographs, use fast film and expose in the same manner that you would for a fixed-point image.

6. Tracking and Telescope Techniques

Although a fairly advanced level of astrophotography can be attained with conventional cameras and lenses fixed on tripods, it is necessary to use tracking techniques when using long exposures if you do not want trailing. Tracking entails aligning a camera on a mount with the celestial pole so that it rotates with Earth's axis and follows the sky. The simplest tracking devices consist of homemade platforms that can yield impressive images when used properly. Another option is to purchase a basic equatorial mount with a simple clock drive. These kinds of mounts allow photographers to make exposures of ten minutes or less and can handle lenses ranging from wide-angle to moderate telephoto focal lengths.

Tracking is also required for most photographs taken with a telescope. Telescope mounts that are suitable for astrophotography are of higher quality and are significantly more expensive than those designed for beginning and intermediate visual observers. The two most common ways that images are made with telescopes are piggybacking a camera and lens on top of the telescope and by attaching the camera body directly to the telescope's optical path. Both methods enable the observer to guide the telescope and make tiny intermittent corrections that ensure the telescope accurately follows the sky.

Basic Tracking

It is easy and inexpensive to make tracked images using a device called a barn door tracker. These are capable of exposures up to about five minutes and can handle lenses up to 135mm. Such units are capable of taking excellent photographs when used within their limitations and are inexpensive to construct. Basic units are based on two hinged boards that are hand-driven by a quarter-inch bolt. More sophisticated designs are available that incorporate motors and articulated arms and can track longer exposures with less error. Several

Facing Page—Tracking allows dimmer stars to record on film. Cassiopeia was exposed for one minute (top) and two minutes (bottom) respectively on a barn door tracker. Lens: 50mm. Film: Kodak E100SW.

designs for variations on the barn door mount can be found by searching on the Internet.

Building a Barn Door Tracker. Depending on need and desire, barn door trackers can be constructed at various levels of sophistication. This lightweight design is for a tracker that can be set on a camera tripod and operated manually. It is particularly suitable for hiking and backpacking where weight and size are important considerations.

Barn door trackers can be constructed at various levels of sophistication.

The materials for building the tracker can be found at almost any building supply store. The specific materials required are listed below.

Materials Needed to Construct a Barn Door Tracker	
Quantity	Material
2	softwood boards (nominal $\frac{3}{4}$" x 6"), 12" to 14" long
2	$\frac{1}{4}$", 20-threads-per-inch tee-nuts
1	piece of continuous (e.g., piano) hinge, 5" long
1	1" diameter dowel, 5" long
1	$\frac{3}{8}$" diameter, 16-threads-per-inch carriage bolts, 6" long
1	$\frac{1}{4}$" diameter, 20-threads-per-inch carriage bolts, 4" long
1	$\frac{1}{4}$" hexagonal nut, 20 threads-per-inch
1	$\frac{1}{4}$" acorn nut, 20 threads-per-inch
1	$\frac{3}{4}$" diameter plastic pipe, 6" to 8" long
2	single hole pipe straps for $\frac{3}{4}$" diameter pipe
1	knurled hose bibb handle
1	ball head such as a Manfrotto (Bogen) 3009
1	medium to large rubber band

1. Attach the hinge to the boards after ensuring the boards are squared up. A good way to do this is to align one edge of the boards with a straightedge while fastening the hinge. When closed, the boards should line up like a closed book.

2. Open the boards and lay them with the hinge pin on the top side. Measure $11\frac{7}{16}$" from the center of the hinge pin to a point along the centerline of the bottom board. Make a small indentation with a nail or punch, and drill a $\frac{5}{16}$" hole through the bottom board. Install a tee nut into the hole from the top side of the top board. Use a hammer or mallet to firmly seat the tee nut. Drill another $\frac{5}{16}$" hole in the center of the bottom board and install the second tee nut from the top side.

3. Drill a $\frac{3}{8}$" hole in the center of the top board. Drill another $\frac{3}{8}$" hole through the longitudinal axis of the dowel. This can be done by supporting the dowel in a vise and using a spade bit of sufficient length to drill the hole.

4. Close the boards and install the pipe along the hinge with the single hole pipe straps fastened to the top board.

5. Place the hose bibb handle at the end of the ¼" carriage bolt and secure with the ¼" hexagonal nut. Thread the bolt through the tee-nut furthest from the hinge from the bottom side of the bottom board. Thread the acorn nut on the end of the carriage bolt.

6. Insert the ⅜" carriage bolt through the hole in the top board from the bottom side. Place the dowel over the bolt and secure with the ball head. Close the boards and wrap the rubber band around the ends of the boards to prevent the mount from flopping about when carried.

When ready to use, attach a camera to the ball head on the mount, and then attach the mount to the head on the tripod using the tee-nut in the center of the bottom board.

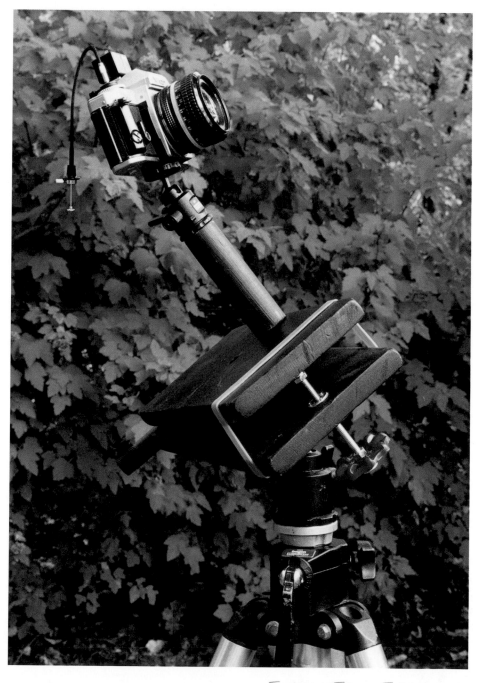

Although there are several designs available for barn door trackers, this version is simple, inexpensive, and lightweight.

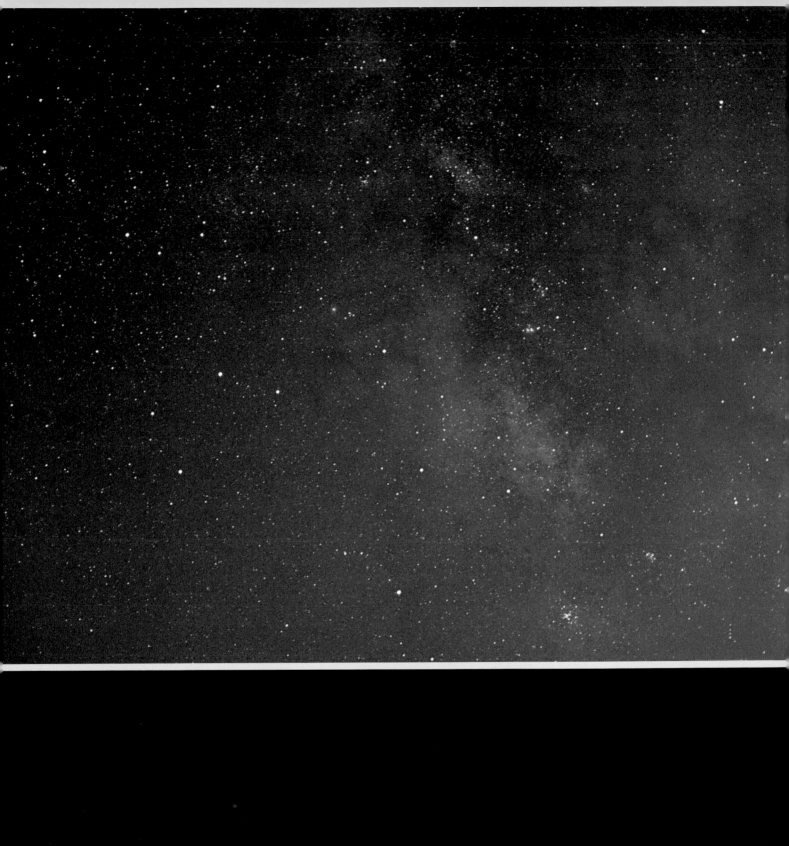

Barn Door Tracker Rotation Intervals	
Handle Rotation	Interval
1/4 turn	15 seconds
1/6 turn	10 seconds
1/8 turn	7.5 seconds
1/12 turn	5 seconds

Facing Page—Don't underestimate what a simple barn door tracker can do. This image shows the Milky Way adjacent to Sagittarius. Lens: 50mm. Exposure: 3 minutes at f/2.8. Film: Konica Centuria 800.

To use a barn door tracker, set the tripod on a firm surface with the hinge on the west side. Using the tripod adjustments, align the axis of the hinge with the celestial pole by sighting Polaris through the pipe. Once the camera is focused and aimed at the subject, you are ready to begin taking photographs. The basic principle behind the barn door tracker is that turning the bolt at a rate of one revolution per minute will cause the board holding the camera to move at the same rate as the sky. The key to making a good image is to turn the screw carefully to avoid vibrating the camera and to maintain an accurate rate of rotation. It is unnecessary to turn the handle constantly. If you are using a knurled hose bibb handle to turn the bolt, the knurls provide a useful reference for determining how far to turn in a given period. Hose bibb handles generally have six, eight, or twelve knurls, which allow the handle to be turned at fairly precise distances. To maintain a one-revolution-per-minute speed, turn the handle at one of the rates shown in the chart on the left.

With lenses of 50mm focal length or less, turning the handle one-quarter turn four times each minute will produce acceptable images. Lenses with focal lengths up to 105mm should be turned at least eight times per minute, and 135mm lenses should be turned twelve times per minute. A simple way to monitor the time is to illuminate your watch with a small flashlight on a lanyard around your neck. Some astrophotographers mount stopwatches on the barn door mount and illuminate them with a small light source such as a red light-emitting diode (LED).

To begin an exposure, activate the self-timer (if your camera has one) on your camera with the shutter speed set to Bulb (B). Lock the cable release and let go before the shutter opens. With practice, you can start the self-timer so that the shutter is released when the second hand on the watch is at an easy-to-read location. For example, if your camera has a ten-second self-timer and you want to start the exposure when the second hand is at 12, you will trip the cable release when the second hand reaches 10.

Equatorial Mounts. Advanced designs of barn door trackers that incorporate motors and articulated arms are available, but the expense and time to construct them make acquiring a motorized equatorial mount (the kind used for telescopes) a practical alternative. The most popular variety of equatorial mount is the German equatorial mount. These mounts have a polar axis that is aligned with the celestial pole and a declination axis that allows for adjustments to the north and south. Some vendors provide adapter plates that allow you to install a ball head on the mount. However, most mounts can accommodate a ball head by inserting a bolt through one of the holes for attaching telescopes. When used with heavy instruments such as telescopes, German equatorial mounts need counterweights that are attached opposite the side where the instrument is attached. They are not necessary when only a camera is attached.

Many German equatorial mounts have polar alignment scopes that simplify the alignment process. To align the mount, look through the alignment scope and adjust the mount until Polaris is lined up within the reticle. It is a little harder to align a German equatorial mount without an alignment scope. A satisfactory way is to lock the axes with the declination axis set at +90 degrees, point the polar axis of the mount at Polaris, and move the mount vertically and horizontally until Polaris is centered in the viewfinder of the camera. While neither of these alignment methods are precise enough for through-the-telescope photography, they are sufficient for the exposure times and focal lengths that are appropriate for barn door mounts.

Another popular equatorial mount is the fork mount, which consists of two tines that support the telescope and allow it to rotate in declination. The tines are supported on a circular base that can rotate in right ascension when supported at the proper angle. To achieve the proper angle, the base is attached to an equatorial wedge that allows it to be tilted so it can be aligned with the celestial pole. Fork mounts are generally limited to use with short astronomical instruments such as Schmidt-Cassegrain telescopes.

Telescope Photography. Although many people want (or at least initially think they want) to begin astrophotography by photographing through a telescope, there are good reasons to wait until you become proficient at using a camera and tripod and simple tracking devices. One reason to wait is that it can be extremely difficult to locate astronomical objects without having a good working knowledge of the night sky. By working with conventional gear, you will develop better habits for working in the dark and become more adept at seeing and recognizing celestial objects. Furthermore, using equipment you are already familiar with makes it that much easier to concentrate on the image you are trying to make instead of fiddling with the equipment you are trying to use.

Telescopes take a lot of time to set up for astrophotography, and you generally get fewer images per session because the exposures are longer. Without experience, trying to find faint fuzzy objects with cantankerous equipment can be an exercise in frustration and aggravation. It is much easier to learn astrophotography with cameras mounted on tripods or basic tracking devices because you create images faster and increase your experience in a shorter time.

Be aware that telescopes that are suitable for astrophotography are expensive.

All the factors that go into selecting an adequate telescope for astrophotography are beyond the scope of this book. However, you should be aware that telescopes that are suitable for astrophotography are expensive. Since it takes time and experience to assess what your needs will be, a hasty purchasing decision is likely to be regretted. It is highly recommended that you try using various types of telescopes before purchasing one. A good way to do this is to attend a star party put on by a local or regional astronomy club. These events are usually open to the public, and visitors have the opportunity to see and to use different kinds of equipment, ask questions, and learn about some of the aggravations associated with telescope photography. For

example, you can evaluate issues such as portability, ease of setup, and rigidity that are never highlighted in manufacturers' advertisements.

None of this is said with the intent of discouraging anyone from pursuing telescope astrophotography. The advent of modern films and better quality amateur equipment has made this an area where serious amateurs can excel. However, astrophotography at this level is very demanding of equipment and technique and can be very frustrating for those who lack experience with the basic techniques. It is also noteworthy that even the best telescope photographers use camera and tripod setups for some of their work—not because it is easier, but because simple gear is the best suited for certain kinds of astrophotography.

Basic Considerations. When considering through-the-telescope photography, the quality of the mount is a critical factor. Not only must the mount be rigid enough to support a moving load, it must be precisely built to meet the demands of enabling long focal length instruments to track the sky. Most commercially available telescopes do not come with mounts beefy enough to facilitate through-the-telescope astrophotography, although quite a few are adequate for piggyback astrophotography with moderate telephoto lenses. All mounts that are adequate for astrophotography are motor driven with controls to enable small adjustments during the exposure. However, not all of the mounts that have motor drive options are sufficiently robust for astrophotography. As a general rule, if the manufacturer does not explicitly represent that a particular combination of mount and telescope are suitable for astrophotography, it probably will not perform well.

Telescope optics are also important. Contrary to popular belief, the main purpose of a telescope is not to magnify a view. The most important capability is the ability to collect light through a large aperture and concentrate it through a small eyepiece. In other words, the most valuable function of a telescope is to make dim objects brighter. Unlike photographic lenses, the optical characteristics of astronomical telescopes are designated by the diameter of their physical apertures and their focal ratios. For example, a 200mm, f/4 photographic lens has a focal length of 200mm, a focal ratio of f/4, and a physical aperture of 50mm (200mm ÷ 4). A 200mm, f/4 telescope has a focal length of 800mm (200mm x 4), a focal ratio of f/4, and a physical aperture of 200mm.

The three most common types of astronomical telescopes are the refractor, Newtonian reflector, and the Schmidt-Cassegrain designs. Each type has its advantages and disadvantages and its proponents and detractors. There is no perfect design for every application. Furthermore, practical considerations such as cost and portability need to be considered.

Refractors have a main lens that transmits light to the end of the telescope tube where the eyepiece is located. The refractors that are most suitable for astrophotography have apochromatic lenses (free of color aberrations) and fairly fast focal ratios between f/5 and f/8. They are very expensive. The less

Contrary to popular belief, the main purpose of a telescope is not to magnify a view.

expensive achromatic refractors are unable to focus all wavelengths of light equally, which results in purple halos around bright stars and the edge of the Moon. Achromatic refractors with apertures under 100mm show lower amounts of color residuals but typically have high focal ratios that make astrophotography difficult. In addition, most low-end refractors do not have enough back focus to enable a camera to focus at infinity. Because the glass lenses in refractors are difficult to manufacture in large sizes, they become increasingly expensive as the physical aperture increases.

Reflectors use a concave primary mirror at the base of the tube to collect and focus light onto a secondary mirror mounted near the aperture of the tube. This secondary mirror reflects the image through an opening at the side of the main tube and into the eyepiece. The Newtonian design, the most popular, uses a flat secondary mirror. The advantages of Newtonian reflectors is that they do not have color aberrations and are the least expensive telescopes per millimeter of aperture. The disadvantages are their bulk and the need to collimate the optics after transporting the telescope to a site.

The Newtonian design, the most popular, uses a flat secondary mirror.

Schmidt-Cassegrain telescopes combine the large primary mirror of a reflector with a lens at the top of the tube that corrects for optical aberrations and supports a secondary mirror that reflects light back to the eyepiece through a hole at the center of the primary mirror. These telescopes tend to have slow focal ratios (e.g., f/10) and long focal lengths (e.g., 2000mm). For astrophotography with Schmidt-Cassegrain telescopes, it is common to use a telecompressor, which will increase the focal ratio to f/6.3 and reduce the focal length to about 1250mm. The main advantage of this design is its compactness and the ready availability of accessories for astrophotography. The major disadvantages are lower contrast than other designs and higher focal ratios.

So You Have to Shoot Through a Telescope. The cost and effort required to make images through the telescope can be daunting and may tempt many people to see if they can get by with lesser equipment. If you feel you cannot resist the temptation, here are some pointers on how to minimize the damage and maximize the learning that comes from experience.

Don't believe that attaching a camera adapter to a low-end telescope will allow you to make images. Most low-end refractors and many Newtonian telescopes do not have sufficient back focus to permit a camera to focus at infinity. If you have such a telescope, there is a technique that will allow you to take reasonably good images called the afocal method. This method requires one tripod for the camera and a second one for the telescope. Set up the telescope to view a bright object such as the Moon and quickly set the camera with the lens pointing into the eyepiece as close as possible. Focus the camera until the image is clear, and make the image before the object moves out of view of the telescope.

For exposure purposes, the effective focal ratio can be determined by multiplying the focal length of the camera lens by the focal length of the telescope

and then dividing the product by the focal length of the eyepiece and by the diameter of the telescope objective. For example, a 60mm, f/11 telescope will have a focal length of 660mm (60mm x 11). If used with a 25mm eyepiece and a camera with a 50mm lens, the effective focal ratio will be:

$$(50mm \times 660mm) \div (25mm \times 60mm) = f/22$$

The problem with such a high focal ratio is that the exposure time to avoid trailing will be so short that the only practical celestial object to photograph will likely be the Moon. The difficult part of the experience will be aligning the telescope and camera sufficiently fast to make the image. An alternative approach, one that can even be used with digital cameras, is to use a coupling device that attaches to the eyepiece and allows you to attach a camera using the threaded tripod socket. This obviates the need to use a tripod to hold the camera.

Piggyback Photography. The easiest way to begin guided astrophotography with a telescope is to piggyback a camera and lens on top of an equatorially mounted telescope with a piggyback adapter. Depending on the lens used, the camera is attached either directly to the piggyback adapter or to a tripod head attached to the adapter. Attaching the camera directly to the adapter is more rigid than attaching it to a tripod head but does not allow much flexibility in aiming the camera.

The telescope is guided through the exposure using a guiding eyepiece that has illuminated crosshairs. By superimposing the crosshairs onto a star, you can discern whether the mount is accurately tracking the sky and make intermittent corrections to the right ascension and declination axes. Since the camera is attached to the telescope, it will record celestial objects without trailing provided the telescope is accurately guided.

. . . do not overestimate the magnification needed for deep-sky astrophotography.

Piggyback astrophotography provides good experience in aligning your telescope with the celestial pole and in guiding the telescope. One advantage of piggybacking is that you can start with wide-angle lenses, which are very tolerant of guiding error, and move up to long telephoto lenses as your skill increases. Also, do not underestimate the capabilities of piggyback photography. Camera lenses are designed for photography and tend to be well corrected optically and have reasonably fast focal ratios compared to telescopes. They are generally better suited for photography than most telescopes. Likewise, do not overestimate the magnification needed for deep-sky astrophotography. Most telescopes have focal lengths ranging from 700mm to 1200mm and some premium instruments have focal lengths closer to 400mm. Lenses in the range of 135mm to 400mm have focal lengths that are reasonably close to those common to astronomical telescopes and are capable of making impressive images.

Prime Focus Photography. The next step is taking photographs through the telescope. In the most straightforward mode, a camera adapter with a T-ring

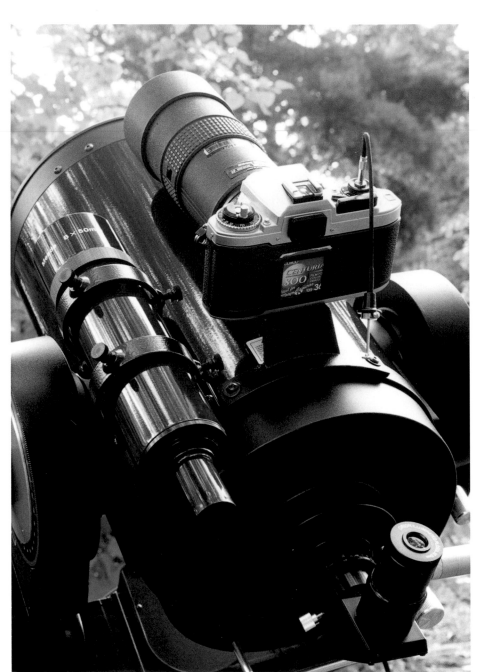

The advantage of using a guidescope is a wide field of view. . . .

This Schmidt-Cassegrain telescope is set up for piggyback astrophotography.

is attached to the telescope in place of the eyepiece or prism. The camera is then attached to the T-ring. This setup is sufficient for terrestrial and lunar photography but cannot be used by itself for photographing deep-sky objects, because telescopes need to be guided for all but the shortest exposures.

One common means of guiding is to use a separate guidescope attached to the imaging telescope. By viewing through a guiding eyepiece attached to the guidescope, the astrophotographer can make corrections as needed. The advantage of using a guidescope is a wide field of view, and you will have more choices of stars for guiding. The disadvantage of using a guidescope is that any flexure between the two telescopes during the exposure will result in disrupted images.

The more popular way of guiding telescopes, particularly Schmidt-Cassegrain telescopes, is the off-axis guider. These devices are similar to camera adapters except that they have a prism in the tube that picks off a small segment of the imaged field and transmits it to a guiding eyepiece. If a suitable guide star is in the field of view, you make corrections by ensuring that the crosshairs in the eyepiece do not move significantly from the guide star. The downside is that finding a guide star is often difficult. When the telescope is pointed directly at the desired object, it is not uncommon to find no

The downside is that finding a guide star is often difficult.

The North-America Nebula, in Cygnus, is a good subject for piggyback astrophotography. Lens: 135mm. Exposure: 5 minutes at f/2.8. Film: Konica Centuria 800.

stars suitable for guiding. By patiently making adjustments to the off-axis guider and moving the telescope around a bit, you can usually find a suitable star. However, the process can put extreme demands on your patience. With experience, most astrophotographers can find a star before the Sun rises.

Sometimes more magnification is needed than prime focus photography can provide. For many photographers, teleconverters are an easy option since they may already have these devices and can use them for other applications. Using a teleconverter is simple—merely attach it to the camera and then to the T-ring attached to the telescope. Most teleconverters increase the magnification by 1.4 or 2 times. They also reduce the intensity of light reaching the film, which means that a longer exposure time will be required. To determine

Sometimes more magnification is needed than prime focus photography can provide.

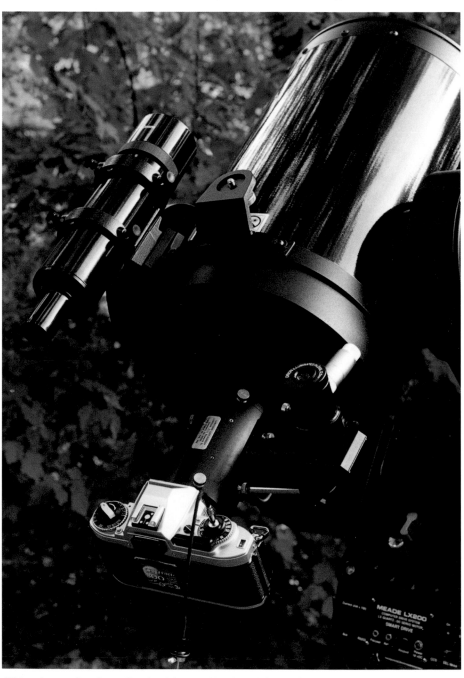

This telescope has been fitted with an off-axis guider with camera and guiding eyepiece attached.

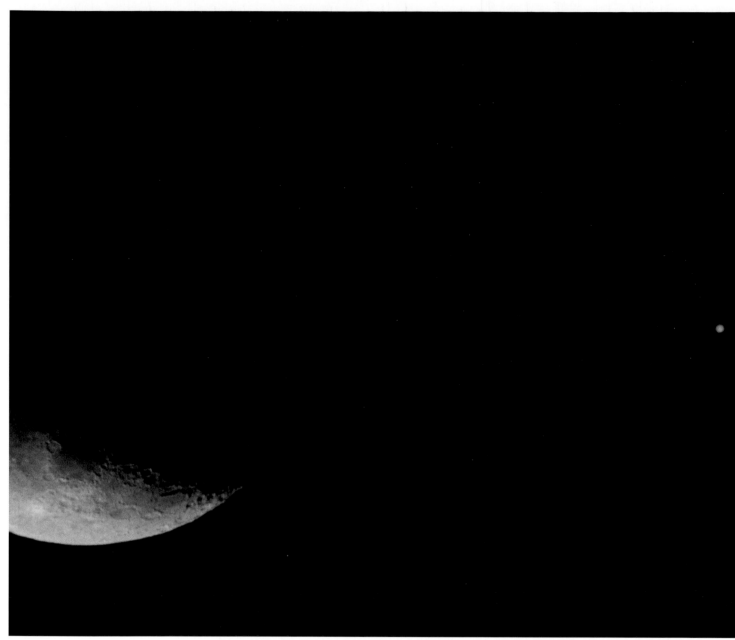

A 2x teleconverter was used on an 200mm f/5 Newtonian reflector to make this image of Jupiter and the Moon.

the effective focal ratio of the telescope with a teleconverter attached, multiply the focal ratio of the telescope by the magnification factor of the teleconverter. For example, the effective ratio of an f/5 telescope will be f/7 with a 1.4x teleconverter and f/10 with a 2x teleconverter.

Another option to increase magnification is to use a Barlow lens between the telescope and the T-ring. A Barlow lens is a telescope accessory that increases the magnification of eyepieces but can also be used with camera adapters. While teleconverters magnify the central portion of an image, Barlow lenses rely on the optical concept of negative projection. Most Barlow lenses have a magnification of 2x although some have 3x. The advantages of a Barlow lens over a teleconverter is that they can be used with eyepieces for visual applications. Additionally, if your telescope has insufficient back focus

. . . Barlow lenses rely on the optical concept of negative projection.

to focus a camera at infinity, a Barlow lens might allow the camera to achieve focus.

If even more magnification is needed, the best option is to use eyepiece projection. Eyepiece projection consists of placing the telescope eyepiece in front of the camera using a special holder. Depending on the focal length of the eyepiece, this method allows for greater magnification than with teleconverters or Barlow lenses, but at the expense of much higher effective focal ratios.

The preceding description covers the basics associated with telescope photography. In addition to quality telescopes, beefy mounts, guidescopes, and off-axis guiders, other accessories such as coma correctors and field flatteners may be necessary for good imaging. Advanced astrophotographers may use CCD cameras, auto-guiders, hypersensitized film, and digital processing techniques to enhance their images. This kind of astrophotography can be very rewarding but is very demanding of time and resources. Mastering other kinds of astrophotography first allows you to learn how to navigate the night sky, gives you experience in working with equipment in the dark, and provides the opportunity to make some great images.

This kind of astrophotography can be very rewarding. . . .

Glossary

Aberration—A flaw in optics that results in a soft or distorted image.

Altitude—The angle between an object and the true horizon.

Angular distance—The measure of the angle between two locations.

Aperture—The diameter of the widest opening of a lens or telescope.

Apogee—The farthest point from Earth in the orbit of the Moon.

Arc—In astronomy, an angular measurement of a part of a circle.

Arc minutes—There are sixty minutes (') of arc in 1 degree.

Arc seconds—There are sixty seconds (") of arc in one arc minute.

Asterism—A subset of stars within a constellation that form a shape. The Big Dipper is an asterism within the constellation Ursa Major.

Azimuth—The angle around the horizon measured eastward between an object and true north.

Celestial equator—The projection of Earth's equator upon the celestial sphere.

Celestial poles—The projection of Earth's poles onto the celestial sphere.

Celestial sphere—An imaginary sphere of infinite radius that is centered on Earth and used to map objects for astronomical observing.

Corona—A halo of light surrounding an object such as the Sun or the Moon.

Declination (Dec.)—The element of the equatorial coordinate system that is roughly analogous to latitude on Earth's surface. Declination is measured north and south of the celestial equator in degrees, minutes, and seconds of arc. The celestial equator is defined as being at declination 0 degrees. The north and south celestial poles are defined as being at +90 and -90 degrees, respectively.

Deep-sky object—An object that is outside the solar system.

Degree—An angular unit of measure. There are 360 degrees in a circle.

Ecliptic—The path that the Sun, the Moon, and the planets follow across the sky.

Ephemerides—Tables that give the coordinates of an object at regular intervals of time.

Equinox—The moment the Sun crosses the celestial equator. The equinox in March marks the beginning of spring in the northern hemisphere, and the equinox in September marks the beginning of autumn.

Equatorial coordinates—A system of mapping celestial objects by their right ascension and declination.

Focal ratio—The ratio of the focal length to the aperture of a lens or telescope.

Magnitude—The units used to describe the brightness of astronomical objects. The smaller the numerical value, the brighter the object.

Occultation—An event where a celestial object passes between an observer and another celestial object. A solar eclipse is an occultation of the Sun by the Moon.

Perigee—The nearest point from Earth in the orbit of the Moon.

Polaris—The North Star, which lies very close to the north celestial pole.

Right ascension (R.A.)—The element of the equatorial coordinate system that is roughly equivalent to longitude on Earth's surface. Right ascension is measured eastward in hours, minutes, and seconds of time. There are twenty-four hours of right ascension.

Setting circles—Circles on an equatorial platform that indicate the right ascension and declination of where an instrument is pointing.

True north—The direction to the geographic north pole. A compass points toward the magnetic north pole and must be corrected with a declination factor to indicate true north.

Zenith—The point in the sky directly above an observer.

Index

OTHER BOOKS FROM

Amherst Media®

Also by Bert P. Krages, Esq. . . .

Legal Handbook for Photographers

While most photographic experiences do not involve confrontation or legal risk, situations do arise where failing to know one's legal rights can mean losing a photo opportunity or incurring liability. Insight into the law can make you a more effective photographer because it enables the exercise of judgment that allows you to achieve your objectives—even in difficult or risky situations. Among the topics outlined in this comprehensive book are: how laws are made; law enforcement on the local and national levels; copyright protection; property rights; unlawful seizures of film and equipment, and more. $19.95 list, 8½x11, 128p, 40 b&w photos, order no. 1726.

Restoring the Great Collectible Cameras (1945–1970)
Thomas Tomosy

More step-by-step instruction on how to repair collectible cameras. Covers postwar models. Hundreds of illustrations show disassembly and repair. $34.95 list, 8½x11, 128p, 200 b&w photos, index, order no. 1573.

Big Bucks Selling Your Photography, Revised Ed.
Cliff Hollenbeck

A comprehensive business package. Includes starting up, pricing, creating successful portfolios, selling on the Internet, and setting financial and creative goals. Organize your business planning, bookkeeping, and taxes. $17.95 list, 8½x11, 128p, 30 b&w photos, order no. 1177.

Infrared Photography Handbook
Laurie White

Covers black and white infrared photography: focus, lenses, film loading, film speed rating, batch testing, paper stocks, and filters. Black & white photos show how IR film reacts in a variety of photo situations. $29.95 list, 8½x11, 104p, 50 b&w photos, charts & diagrams, order no. 1419.

Outdoor and Location Portrait Photography 2nd Ed.
Jeff Smith

Learn to work with natural light, select locations, and make clients look their best. Packed with step-by-step discussions and illustrations to help you shoot like a pro! $29.95 list, 8½x11, 128p, 80 color photos, index, order no. 1632.

Creating World-Class Photography
Ernst Wildi

Learn how any photographer can create technically flawless photos. Features techniques for eliminating technical flaws in all types of photos—from portraits to landscapes. Includes the Zone System, digital imaging, and much more. $29.95 list, 8½x11, 128p, 120 color photos, index, order no. 1718.

Black & White Portrait Photography
Helen T. Boursier

Make money with black & white portrait photography. Learn from top shooters! Studio and location techniques, with tips on preparing your subjects, selecting settings and wardrobe, lab techniques, and more! $29.95 list, 8½x11, 128p, 130 b&w photos, index, order no. 1626.

The Beginner's Guide to Pinhole Photography
Jim Shull

Take pictures with a camera you make from stuff you have around the house. Develop and print the results at home! Pinhole photography is fun, inexpensive, educational and challenging. Makes a great gift for any photo enthusiats—from children to adults. $17.95 list, 8½x11, 80p, 55 b&w photos, charts & diagrams, order no. 1578.

Handcoloring Photographs Step by Step

Sandra Laird and Carey Chambers

Learn to handcolor photographs step-by-step with the new standard in handcoloring reference books. Covers a variety of coloring media and techniques. $29.95 list, 8½x11, 112p, 100 b&w and color photos, order no. 1543.

Essential Skills for Nature Photography

Cub Kahn

Learn the skills you need to capture landscapes, animals, flowers, and the entire natural world on film. Includes: selecting equipment, choosing locations, evaluating compositions, filters, and much more! $29.95 list, 8½x11, 128p, 60 b&w and color photos, order no. 1652.

Photographer's Guide to Polaroid Transfer, *2nd Ed.*

Christopher Grey

Step-by-step instructions make it easy to master Polaroid transfer and emulsion lift-off techniques and add new dimension to your photographic imaging. Fully illustrated to ensure great results the first time! $29.95 list, 8½x11, 128p, 100 color photos, order no. 1653.

Professional Secrets of Wedding Photography *2nd Ed.*

Douglas Allen Box

Top-quality portraits are analyzed to teach you the art of professional wedding portraiture. Lighting diagrams, posing information, and technical specs are included for every image. $29.95 list, 8½x11, 128p, 80 color photos, order no. 1658.

Photo Retouching with Adobe® Photoshop® *2nd Ed.*

Gwen Lute

Teaches every phase of the process, from scanning to final output. Learn to restore damaged photos, correct imperfections, create realistic composite images, and correct for dazzling color. $29.95 list, 8½x11, 120p, 100 color images, order no. 1660.

Creative Lighting Techniques for Studio Photographers, *2nd Ed.*

Dave Montizambert

Whether you are shooting portraits, cars, tabletop, or any other subject, Dave Montizambert teaches you the skills you need to take complete control of your lighting. $29.95 list, 8½x11, 120p, 80 color photos, order no. 1666.

Secrets of Successful Aerial Photography

Richard Eller

Learn how to plan a shoot and take images from the air. Discover how to control camera movement, compensate for environmental conditions and compose outstanding aerial images. $29.95 list, 8½x11, 120p, 100 b&w and color photos, order no. 1679.

Professional Secrets of Nature Photography

Judy Holmes

Covers every aspect of making top-quality images, from selecting the right equipment, to choosing the best subjects, to shooting techniques for professional results every time. $29.95 list, 8½x11, 120p, 100 color photos, order no. 1682.

Composition Techniques from a Master Photographer

Ernst Wildi

Composition can make the difference between dull and dazzling. Master photographer Ernst Wildi teaches you his techniques for evaluating subjects and composing powerful images in this beautiful color book. $29.95 list, 8½x11, 128p, 100 color photos, order no. 1685.

Macro & Close-up Photography Handbook

Stan Sholik and Ron Eggers

Learn to get close and capture breathtaking images of small subjects—flowers, stamps, jewelry, insects, etc. Designed with the 35mm shooter in mind, this is a comprehensive manual full of step-by-step techniques. $29.95 list, 8½x11, 120p, 80 b&w and color photos, order no. 1686.

The Art and Science of Butterfly Photography

William Folsom

Learn butterfly behavior (feeding, mating, and migrational patterns), when to photograph, how to lure them, and techniques for capturing breathtaking images of these colorful creatures. $29.95 list, 8½x11, 120p, 100 b&w and color photos, order no. 1680.

The Practical Manual of Captive Animal Photography

Michael Havelin

Learn the environmental advantages of photographing animals in captivity, and how to take natural-looking photos of subjects in zoos, preserves, aquariums, etc. $29.95 list, 8½x11, 120p, 100 b&w photos, order no. 1683.

Watercolor Portrait Photography
THE ART OF POLAROID SX-70 MANIPULATION
Helen T. Boursier

Create one-of-a-kind images with this surprisingly easy artistic technique. $29.95 list, 8½x11, 128p, 200 color photos, order no. 1698.

Corrective Lighting and Posing Techniques for Portrait Photographers
Jeff Smith

Learn to make every client look his or her best by using lighting and posing to conceal real or imagined flaws—from baldness, to acne, to figure flaws. $29.95 list, 8½x11, 120p, 150 color photos, order no. 1711.

How to Buy and Sell Used Cameras
David Neil Arndt

Learn the skills you need to evaluate the cosmetic and mechanical condition of used cameras, and buy or sell them for the best price possible. Also learn the best places to buy/sell and how to find the equipment you want. $19.95 list, 8½x11, 112p, 60 b&w photos, order no. 1703.

Professional Secrets of Natural Light Portrait Photography
Douglas Allen Box

Use natural light to create hassle-free portraiture. Beautifully illustrated with detailed instructions on equipment, lighting, and posing. $29.95 list, 8½x11, 128p, 80 color photos, order no. 1706.

Portrait Photographer's Handbook
Bill Hurter

Bill Hurter has compiled a step-by-step guide to portraiture that easily leads the reader through all phases of portrait photography. This book will be an asset to experienced photographers and beginners alike. $29.95 list, 8½x11, 128p, 100 color photos, order no. 1708.

Professional Marketing & Selling Techniques for Wedding Photographers
Jeff Hawkins and Kathleen Hawkins

Gain the insight you need to make it in the wedding photography business. This book includes ncludes information on consultations, direct mail, advertising, internet marketing, and much more. $29.95 list, 8½x11, 128p, 80 color photos, order no. 1712.

Photographing Creative Landscapes
Michael Orton

Boost your creativity and bring a new level of enthusiasm to your images of the landscape. This step-by-step guide is the key to escaping from your creative rut and beginning to create more expressive images. $29.95 list, 8½x11, 128p, 70 color photos, order no. 1714.

Advanced Infrared Photography Handbook
Laurie White Hayball

Building on the techniques covered in her *Infrared Photography Handbook*, Laurie White Hayball presents advanced techniques for harnessing the beauty of infrared light on film. $29.95 list, 8½x11, 128p, 100 b&w photos, order no. 1715.

Selecting and Using Classic Cameras
Michael Levy

Discover the charms and challenges of using classic cameras. Folders, TLRs, SLRs, Polaroids, rangefinders, spy cameras, and more are included in this gem for classic camera lovers. $17.95 list, 6x9, 196p, 90 b&w photos, order no. 1719.

Traditional Photographic Effects with Adobe® Photoshop®, 2nd Ed.
Michelle Perkins and Paul Grant

Use Photoshop to enhance your photos with handcoloring, vignettes, soft focus, and much more. Every technique contains step-by-step instructions for easy learning. $29.95 list, 8½x11, 128p, 150 color images, order no. 1721.

Master Posing Guide for Portrait Photographers
J. D. Wacker

Learn the techniques you need to pose single portrait subjects, couples, and groups for studio or location portraits. Includes techniques for photographing weddings, teams, children, special events and much more. $29.95 list, 8½x11, 128p, 80 photos, order no. 1722.

Photographic Lenses
PHOTOGRAPHER'S GUIDE TO CHARACTERISTICS, QUALITY, USE AND DESIGN
Ernst Wildi

Gain a complete understanding of the lenses through which all photographs are made—both on film and in digital photography. $29.95 list, 8½x11, 128p, 70 color photos, order no. 1723.

The Art of Color Infrared Photography

Steven H. Begleiter

Color infrared photography will open the doors to a new and exciting photographic world. This book shows readers how to previsualize the scene and get the results they want. $29.95 list, 8½x11, 128p, 80 color photos, order no. 1728.

The Art of Photographing Water

Cub Kahn

Learn to capture the interplay of light and water with this beautiful, compelling, and comprehensive book. Packed with practical information you can use right away! $29.95 list, 8½x11, 128p, 70 color photos, order no. 1724.

Digital Imaging for the Underwater Photographer

Jack and Sue Drafahl

This book will teach readers how to improve their underwater images with digital imaging techniques. This book covers all the bases—from color balancing your monitor, to scanning, to output and storage. $39.95 list, 6x9, 224p, 80 color photos, order no. 1727.

The Art of Bridal Portrait Photography

Marty Seefer

Learn to give every client your best and create timeless images that are sure to become family heirlooms. Seefer takes readers through every step of the bridal shoot, ensuring flawless results. $29.95 list, 8½x11, 128p, 70 color photos, order no. 1730.

Photographer's Filter Handbook

Stan Sholik and Ron Eggers

Take control of your photography with the tips offered in this book! This comprehensive volume teaches readers how to color-balance images, correct contrast problems, create special effects, and more. $29.95 list, 8½x11, 128p, 100 color photos, order no. 1731.

Beginner's Guide to Adobe® Photoshop®, 2nd Ed.

Michelle Perkins

Learn to effectively make your images look their best, create original artwork, or add unique effects to any image. Topics are presented in short, easy-to-digest sections that will boost confidence and ensure outstanding images. $29.95 list, 8½x11, 128p, 300 color images, order no. 1732.

Professional Techniques for Digital Wedding Photography, 2nd Ed.

Jeff Hawkins and Kathleen Hawkins

From selecting equipment, to marketing, to building a digital workflow, this book teaches how to make digital work for you. $29.95 list, 8½x11, 128p, 85 color images, order no. 1735.

Photographer's Lighting Handbook

Lou Jacobs Jr.

Think you need a room full of expensive lighting equipment to get great shots? With a few simple techniques and basic equipment, you can produce the images you desire. $29.95 list, 8½x11, 128p, 130 color photos, order no. 1737.

Beginner's Guide to Digital Imaging

Rob Sheppard

Learn how to select and use digital technologies that will lend excitement and provide increased control over your images—whether you prefer digital capture or film photography. $29.95 list, 8½x11, 128p, 80 color photos, order no. 1738.

Professional Digital Photography

Dave Montizambert

From monitor calibration, to color balancing, to creating advanced artistic effects, this book provides those skilled in basic digital imaging with the techniques they need to take their photography to the next level. $29.95 list, 8½x11, 128p, 120 color photos, order no. 1739.

Group Portrait Photographer's Handbook

Bill Hurter

With images by top photographers, this book offers timeless techniques for composing, lighting, and posing group portraits. $29.95 list, 8½x11, 128p, 120 color photos, order no. 1740.

LIGHTING AND EXPOSURE TECHNIQUES FOR

Outdoor and Location Portrait Photography

J. J. Allen

Meet the challenges of changing light and complex settings with techniques that help you achieve great images every time. $29.95 list, 8½x11, 128p, 150 color photos, order no. 1741.

Toning Techniques for Photographic Prints

Richard Newman

Whether you want to age an image, provide a shock of color, or lend archival stability to your black & white prints, the step-by-step instructions in this book will help you realize your creative vision. $29.95 list, 8½x11, 128p, 150 color and b&w photos, order no. 1742.

The Art and Business of High School Senior Portrait Photography

Ellie Vayo

Learn the techniques that have made Ellie Vayo's studio one of the most profitable senior portrait businesses in the US. $29.95 list, 8½x11, 128p, 100 color photos, order no. 1743.

The Best of Nature Photography

Jenni Bidner and Meleda Wegner

Ever wondered how legendary nature photographers like Jim Zuckerman and John Sexton create their images? Follow in their footsteps as top photographers capture the beauty and drama of nature on film. $29.95 list, 8½x11, 128p, 150 color photos, order no. 1744.

Beginner's Guide to Nature Photography

Cub Kahn

Whether you prefer a walk through a neighborhood park or a hike through the wilderness, the beauty of nature is ever present. Learn to create images that capture the scene as you remember it with the simple techniques found in this book. $14.95 list, 6x9, 96p, 70 color photos, order no. 1745.

Photo Salvage with Adobe® Photoshop®

Jack and Sue Drafahl

This book teaches you to digitally restore faded images and poor exposures. Also covered are techniques for fixing color balance problems and processing errors, eliminating scratches, and much more. $29.95 list, 8½x11, 128p, 200 color photos, order no. 1751.

The Art of Black & White Portrait Photography

Oscar Lozoya

Learn how Master Photographer Oscar Lozoya uses unique sets and engaging poses to create black & white portraits that are infused with drama. Includes lighting strategies, special shooting techniques and more. $29.95 list, 8½x11, 128p, 100 duotone photos, order no. 1746.

The Best of Wedding Photography

Bill Hurter

Learn how the top wedding photographers in the industry transform special moments into lasting romantic treasures with the posing, lighting, album design, and customer service pointers found in this book. $29.95 list, 8½x11, 128p, 150 color photos, order no. 1747.

Success in Portrait Photography

Jeff Smith

Many photographers realize too late that camera skills alone do not ensure success. This book will teach photographers how to run savvy marketing campaigns, attract clients, and provide top-notch customer service. $29.95 list, 8½x11, 128p, 100 color photos, order no. 1748.

Photographing Children with Special Needs

Karen Dórame

This book explains the symptoms of spina bifida, autism, cerebral palsy, and more, teaching photographers how to safely and effectively capture the unique personalities of these children. $29.95 list, 8½x11, 128p, 100 color photos, order no. 1749.

Professional Digital Portrait Photography

Jeff Smith

Because the learning curve is so steep, making the transition to digital can be frustrating. Author Jeff Smith shows readers how to shoot, edit, and retouch their images—while avoiding common pitfalls. $29.95 list, 8½x11, 128p, 100 color photos, order no. 1750.

The Best of Children's Portrait Photography

Bill Hurter

Rangefinder editor Bill Hurter draws upon the experience and work of top professional photographers, uncovering the creative and technical skills they use to create their magical portraits. $29.95 list, 8½x11, 128p, 150 color photos, order no. 1752.

Wedding Photography with Adobe® Photoshop®

Rick Ferro and Deborah Lynn Ferro

Get the skills you need to make your images look their best, add artistic effects, and boost your wedding photography sales with savvy marketing ideas. $29.95 list, 8½x11, 128p, 100 color images, index, order no. 1753.

Web Site Design for Professional Photographers

Paul Rose and Jean Holland-Rose

Learn to design, maintain, and update your own photography web site. Designed for photographers, this book shows you how to create a site that will attract clients and boost your sales. $29.95 list, 8½x11, 128p, 100 color images, index, order no. 1756.

PROFESSIONAL PHOTOGRAPHER'S GUIDE TO

Success in Print Competition

Patrick Rice

Learn from PPA and WPPI judges how you can improve your print presentations and increase your scores. $29.95 list, 8½x11, 128p, 100 color photos, index, order no. 1754.

Step-by-Step Digital Photography

Jack and Sue Drafahl

Avoiding the complexity and jargon of most manuals, this book will quickly get you started using your digital camera to create memorable photos. $14.95 list, 9x6, 112p, 185 color photos, index, order no. 1763.

Advanced Digital Camera Techniques

Jack and Sue Drafahl

Maximize the quality and creativity of your digital-camera images with the techniques in this book. Packed with problem-solving tips and ideas for unique images. $29.95 list, 8½x11, 128p, 150 color photos, index, order no. 1758.

The Best of Teen and Senior Portrait Photography

Bill Hurter

Learn how top professionals create stunning images that capture the personality of their teen and senior subjects. $29.95 list, 8½x11, 128p, 150 color photos, index, order no. 1766.

PHOTOGRAPHER'S GUIDE TO

The Digital Portrait

START TO FINISH WITH ADOBE® PHOTOSHOP®

Al Audleman

Follow through step-by-step procedures to learn the process of digitally retouching a professional portrait. $29.95 list, 8½x11, 128p, 120 color images, index, order no. 1771.

The Portrait Book

A GUIDE FOR PHOTOGRAPHERS

Steven H. Begleiter

A comprehensive textbook for those getting started in professional portrait photography. Covers every aspect from designing an image to executing the shoot. $29.95 list, 8½x11, 128p, 130 color images, index, order no. 1767.

The Master Guide for Wildlife Photographers

Bill Silliker, Jr.

Discover how photographers can employ the techniques used by hunters to call, track, and approach animal subjects. Includes safety tips for wildlife photo shoots. $29.95 list, 8½x11, 128p, 100 color photos, index, order no. 1768.

Digital Photography for Children's and Family Portraiture

Kathleen Hawkins

Discover how digital photography can boost your sales, enhance your creativity, and improve your studio's workflow. $29.95 list, 8½x11, 128p, 130 color images, index, order no. 1770.

MORE PHOTO BOOKS ARE AVAILABLE

Amherst Media®

PO BOX 586
BUFFALO, NY 14226 USA

INDIVIDUALS: If possible, purchase books from an Amherst Media retailer. Contact us for the dealer nearest you, or visit our web site and use our dealer locater. To order direct, visit our web site, or send a check/money order with a note listing the books you want and your shipping address. All major credit cards are also accepted. For domestic and international shipping rates, please visit our web site or contact us at the numbers listed below. New York state residents add 8% sales tax.

DEALERS, DISTRIBUTORS & COLLEGES: Write, call, or fax to place orders. For price information, contact Amherst Media or an Amherst Media sales representative. Net 30 days.

(800)622-3278 or (716)874-4450
Fax: (716)874-4508

All prices, publication dates, and specifications are subject to change without notice. Prices are in U.S. dollars. Payment in U.S. funds only.

WWW.AMHERSTMEDIA.COM

FOR A COMPLETE CATALOG OF BOOKS AND ADDITIONAL INFORMATION